Beyond Bullets

*Creative Journaling Ideas to Customize
Your Personal Productivity System*

Megan Rutell

Ulysses Press

For my three Rutell men.
You fill every page of my life with joy.

Published in the United States by:
Ulysses Press
P.O. Box 3440
Berkeley, CA 94703
www.ulyssespress.com

ISBN: 978-1-61243-757-6
Library of Congress Control Number: 2017952127

Printed in the United States by Versa Press
10 9 8 7 6 5 4 3 2

Acquisitions editor: Bridget Thoreson
Managing editor: Claire Chun
Editor: Renee Rutledge
Proofreader: Shayna Keyles
Front cover design: Justin Shirley
Photographs: Megan Rutell except page 120 Maggie Kan; page 121 Whitney Baker; page 122 (top) Shelby Abrahamsen; page 122 (bottom) Torrie Gass; page 123 (top) Helen Colebrook; page 123 (bottom) Sheena Maglione; page 124 (top) Annora Thoeng; page 124 (bottom) Tímea Kocsisnenagy; pages 125 and 126 (top) Meka Allen; page 126 (bottom) Erin Nichols; page 127 Denise D. Qvist
Interior design and layout: Malea Clark-Nicholson

Distributed by Publishers Group West

CONTENTS

HOW TO USE THIS BOOK

Creative journaling is easy and enjoyable. You can energize every aspect of your life with simple organization and a dash of art, even if you have no experience with journaling. This book goes beyond mere list-making to explore the many ways of transforming a blank notebook into a treasured life companion.

Instead of providing a formula for keeping a journal, this book aims to spark your imagination by showing fun and functional possibilities. We all have different approaches to life, and journaling is no different. For that reason, *Beyond Bullets* does not focus on a single journaling system or philosophy. Whatever style of journaling you favor, this book will provide you with strategies to enrich the experience. You'll find a huge variety of techniques you can apply to your own journaling practice. Use them for planning, productivity, artistic expression, reflections, self-improvement, or fun (hey, we're a wild and crazy bunch, us journaling folk!). This is your journey.

You'll notice this book is structured around two principal motivations for starting a creative journal: Organization and Creativity. Learning to balance these two concepts is a powerful way to manage your schedule and stay motivated to achieve your goals.

Part 1 tackles basic layout possibilities. Discover dominant journaling styles, useful supplies, strategies for developing a routine, and tips on choosing your core pages. What types of tasks do you manage in your life? What level of detail do you need in your schedule? How often do you want to create new pages? Use the templates as a starting point to design your own perfect planning pages. You'll also get a peek at different styles of charts and graphs that can log information in a visual way.

If your journal were a cake, Part 2 would be the icing. Beautiful lettering and sketches entice you to come back for another taste (and make the process feel much less like homework). Even if you have no experience with drawing, you can recreate eye-popping doodles and designs to energize your pages and fill them with color.

Spend some time getting to know the structural options in Part 1. It's so tempting to dive right into artistic pages—I sometimes feel like a magpie chasing jewels: "Look at the pretties!" After all, those creative elements are what attract many of us to journaling in the first place. So, we dive into fancy lettering, intricate doodles, and different colored pens for *everything*. Sure, the pages are gorgeous, but that creative energy waxes and wanes. A dependable structure will give you something to fall back on, even when you don't have time or motivation to be artistic.

That being said, focusing only on planning can feel bland for many people. Creativity without structure is chaotic, but organization without inspiration is lifeless. The two concepts depend on each other. Once you develop your system, the artistic elements will emerge naturally. On the other hand, if you ever feel your journal becoming joyless, indulge in some creative play. It's amazing how much stress you can purge from your task list with a hand-lettered quote and pop of color.

Now that you know how to use this book, you're well-poised to be a creative journaling mastermind. Take your time, be intentional about your planning, and have fun with it!

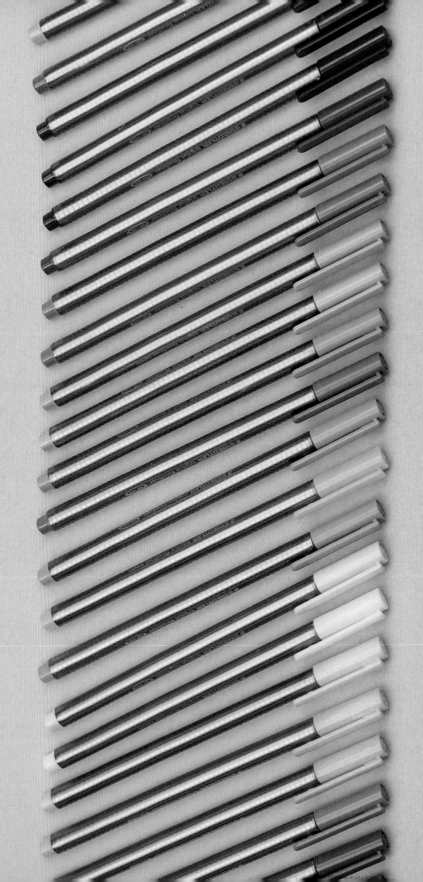

PART I

Organization

"Organizing is what you do before you do something, so that when you do it, it is not all mixed up."

—A.A. MILNE

Modern journaling is more than simply writing your daily thoughts in a notebook. Today's journal enthusiast demands a private space to contemplate life, as well as a system that can be an all-in-one organizational solution. The trick is to keep it all organized from the beginning.

Starting a journal from scratch can be intimidating at first, but it doesn't need to be. Like most other things in life, the process is very simple if you break it down. This section will help you choose a journal, give it purpose, and develop a routine that molds to your lifestyle.

Lines ፨ FROM A ፨ Good Book

"We were the people who were not in the papers. We lived in the blank white spaces at the edges of print. It gave us more freedom. We lived in the gaps between the stories."
— The Handmaid's Tale
MARGARET ATWOOD

"And so with the sunshine and the bursts of leaves growing on the trees, just as things grow in fast mo... beginning over again with the... that familiar conviction that...
The Great Gatsby, F. Scott...

"It is true that those we meet can change us, sometimes so profoundly that we are not the same afterwards, even unto our names." — Life of Pie, YANN M...

"Anyone who ever gave you confidence, you ow...

everywhere...

EUROPE

Paris

What a beautiful city! We flew in on April 9th and didn't wait for jet lag. We explored everythin... favorites w... catacom... sma...

Paris is in the everyday — the... the park, or the hidden ba... truly see Paris from. t...

Italy

Bellissim... the...

TRIP

No...
After... rip, w... ts.

GREENLAND

USA

MEXICO
NICARAGUA
COSTA RICA
& ECUADOR

FIJI

NEW ZEALAND

MONDAY
✓ PACK LUNCH
→ CALL TO CONFIRM RESERVATIONS
→ STAFF MEETING 9:00 - 9:30 AM
▷ PICK UP ALTERATIONS
→ PAY BILLS

THURSDAY
✓ CHECK CAR FLUIDS FOR TRIP
✓ PACK BAGS
✓ ARRANGE PLANT SITTER
✓ CONFIRM PET BOARDING
✓ HOLD MAIL
✓ DOUBLE CHECK HOTEL / RESORT INFO.
→ PLAN ROUTE
✓ CLEAN OUT REFRIGERATOR
➤ POST OFFICE

Saturday
OFF TO THE BEACH

Oops!
SKIPPED
FRI...

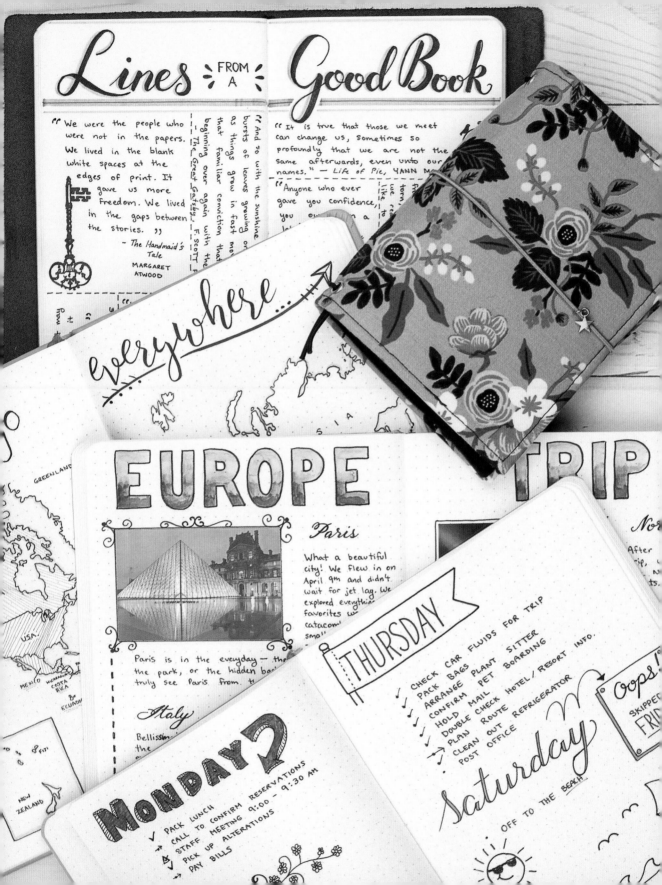

CHAPTER 1

Introduction to Creative Journaling

Journaling is an old, familiar tradition. It calls to mind images of ancient leather logbooks carefully penned by candlelight. The practice goes back centuries. Some of the most prominent figures in history—Benjamin Franklin, Leonardo da Vinci, and Virginia Woolf, among others—kept journals. There's an inherent romance to cataloging life in this way.

In recent years, journaling has experienced an explosive boom in popularity, but with a new twist. Modern journals contain more than long written entries describing the day's events. They've become catch-all sketchbooks, planners, list-keepers, health trackers, and private spaces for self-reflection. The flexibility they offer simply can't be matched by pre-printed calendars and agendas. Creative journal users appreciate the freedom of blank pages because they can design their own layouts and add personal artistic touches. Whether they need fitness charts, simple to-do lists, or space to work out a problem on paper, each page is designed and drawn to suit a specific purpose.

They may not be writing by candlelight anymore, but today's diarists appreciate the value of simplicity. In fact, many of them are abandoning their digital planning tools altogether, preferring the quiet of their notebooks to the distractions of phones, tablets, apps, and alarms constantly competing for attention. Paper offers the ultimate retreat. Journal systems have no software to learn, no technical glitches, no formatting restrictions, and very few required materials.

This latest journaling trend comes at a time when mindfulness is also attracting mainstream attention. Mindfulness and journaling are natural partners in the quest to forge a deeper connection with the lives we lead. Paper provides an atmosphere of quiet to reflect on life events and future goals, while mindful practices can lead to happier, more intentional lives.

Ironically, modern digital tools also help fuel this old-fashioned habit. Social media platforms provide forums for journal

enthusiasts to swap ideas, tips, and various methods for turning blank notebooks into the ultimate life-improvement tools. Professionals can make pages to assist with their jobs, students use their journals as study aides, and hobbyists find a portable place to express their creativity.

Journaling is ultimately a private process, but now it can also be shared across the world in an instant. This sharing of ideas is largely what makes modern journaling so innovative and adaptive. However, I know firsthand that wading through Internet clutter can be distracting and overwhelming. It's my hope that this book can simplify the barrage of advice, layouts, artistic elements, and organization techniques.

Journaling can add many things to your life: focus, relaxation, healing, intention, creativity, direction, and clarity. Complication doesn't have to be a part of it.

WHY DO PEOPLE JOURNAL?

No two people will have exactly the same reasons for keeping a journal. I find most people identify with at least one of the purposes below, but respect your own needs. You should never feel like your journal must fit into someone else's ideal. It's a completely personal journey.

Organization

This is probably the most common reason people choose to take up daily journaling and paper planning. Whether they're trying to organize their homes, schedules, project notes, or stray thoughts, having a place to bring order to chaos can be extremely beneficial.

Most people need to track tasks and appointments to maintain order in their lives. You can use a notebook to organize everything from fitness routines to pet medications. Habitual list-makers enjoy being able to keep everything in one place: lists of quotes, books to read, experiences to try, places to visit, skills to learn, favorite recipes, and so on. Rather than making these lists and forgetting about them, people can turn to their journals as central organizing systems. Many people index the contents of their journals and refer back to old pages year after year.

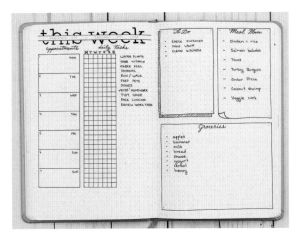

You can also use your journal to organize your mind. Paper can be a powerful tool for processing emotions, weighing actions and consequences, or making a "brain dump" area to alleviate worry.

Mindfulness & Self-Awareness

When it comes to the art and science of living a healthy, happy life, mindfulness is increasingly a central part of the discussion. Overloaded schedules, mental clutter, and electronic distractions weigh heavily on your ability to live fruitfully. Not only does journaling allow you to declutter your mind, it provides clarity about the many things pulling you in different directions.

Being aware of your surroundings can also spark insights into your life. Preserving these moments in a journal amplifies the connection

to your everyday experiences. Writing down experiences, goals, tasks, or reminders can also alleviate stress. It boosts our awareness of emotions, energy levels, and reactions to life's events. This self-awareness makes it possible to manage your weaknesses, but more importantly, it reveals potential you never dreamed existed.

Gratitude, as an extension of mindfulness, has also taken a firm foothold in modern journaling practices. Some users devote full pages each month to documenting the good things in their lives, while others make a page when the mood strikes them. Adding positive habits to your life can increase happiness and energy levels, and reinforce relationships. Since you have contact with your journal on a daily basis, it's the ideal place to explore gratitude and other habits that boost your awareness of the life around you.

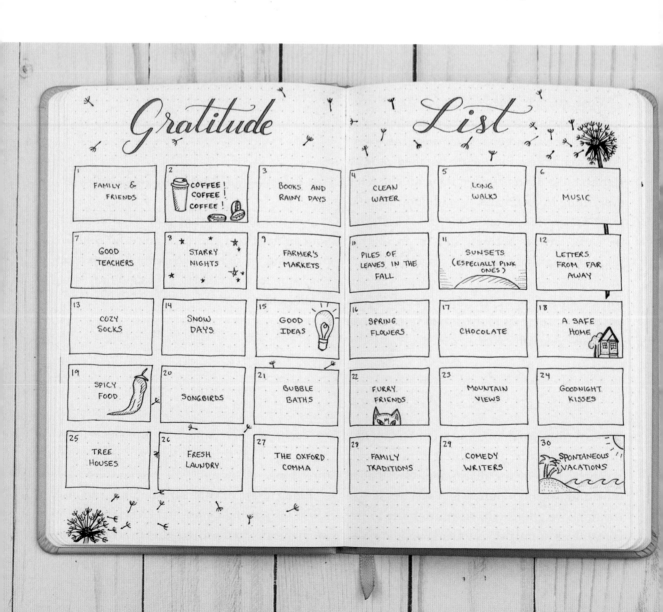

Expression & Enjoyment

Personal enjoyment drives many people in their journaling practices, myself included. It's a very tactile process: touching paper, holding a pen, watching lines of ink appear on the page, and releasing thoughts onto paper. The same can be said for any artistic undertaking like painting, sketching, hand-lettering, scrapbooking, and coloring.

There's also an element of fantasy to journaling that's incredibly alluring. After a hard day at work, jotting down a list of exotic travel destinations feels empowering, as though putting your dreams to paper makes them more attainable.

You can use your journal to entertain yourself with short writing prompts, 30-day art challenges, or practicing new skills. Whether you're a writer, artist, memory-keeper, goal-setter, or traveler, you can find joy and comfort in the pages of your journal.

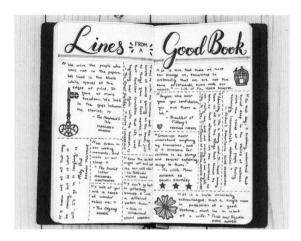

IS IT A HOBBY OR A TOOL?

As journaling has grown in popularity, a cultural divide has developed over whether it should be an enjoyable hobby or a tool for daily living. I really believe it depends on the person. My journal is a little bit of both.

On the other hand, some people journal purely for organizational needs and want absolutely nothing to do with doodles or pretty headers. They're more interested in productivity, and artistic elements only slow them down. That's perfectly fine. If you ever find yourself overwhelmed with the artistic aspects of journaling, simplify.

Since you chose this book, you're probably interested in using your journal for both planning and creativity. I find adding bits of artwork here and there makes me want to use my journal. If I strip away the creative aspects, I begin to lose the joy of the process. Find the balance that works for you, whether it is understated or bursting with color.

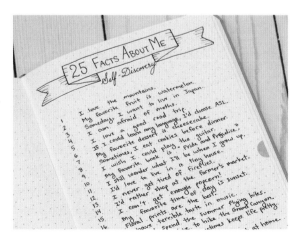

POPULAR JOURNALING STYLES

Each journal is as unique as its creator. From meticulous lists to vibrant sketches, there is no wrong way to keep a journal. You'll see me repeat that throughout this book because I feel it is vital to getting the most out of your experience. So long as you feel comfortable with the style you use, you can't go wrong.

My own journal has proven to me time and again what a powerful tool it is, but only because I do it my way. As you work through each section of this book, consider your lifestyle, personality, and goals. If something doesn't work for you, change it.

I sometimes get emails along the lines of, "I could never make my journal look like that, so what's the point in trying?" This process is not about putting on a show for someone else. No one is judging your private journal, so don't worry about what your pages look like. You don't have to share them with anyone. Even then, most people who post pictures of their journals on social media and blogs do so in the spirit of sharing, not competition. If your pages function and you enjoy creating them, they're serving you well. Celebrate your personal style.

Maybe you're not even sure what your personal style is. I've put together a quick look at some of the dominant styles in journaling today. These aren't hard-and-fast categories; you do not need to pick a team. Just know these varieties exist for you to draw from. Feel free to blur the lines and combine elements from each style. Popular styles can guide you and ignite your creative fires, but only you can determine how to best use your journal!

Traditional Journaling

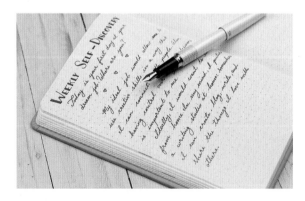

Most people picture traditional journaling when they think of journals or diaries. Pages progress chronologically by date and are typically written in first-person, paragraph format. Other than large blocks of handwritten words, there's no defining aesthetic. In addition to an account of the day, the author might reflect on the significance of events, attempt to unravel a mystery, or record important information for later use. The term "diary" is often used specifically to describe the journal of a young girl, but the differences between a diary and traditional journal are negligible.

This style is especially useful for recording thoughts or feelings at a specific point in life. Some information is difficult to capture in bullet format, photos, or lists. A funny story, for instance, deserves to be written out.

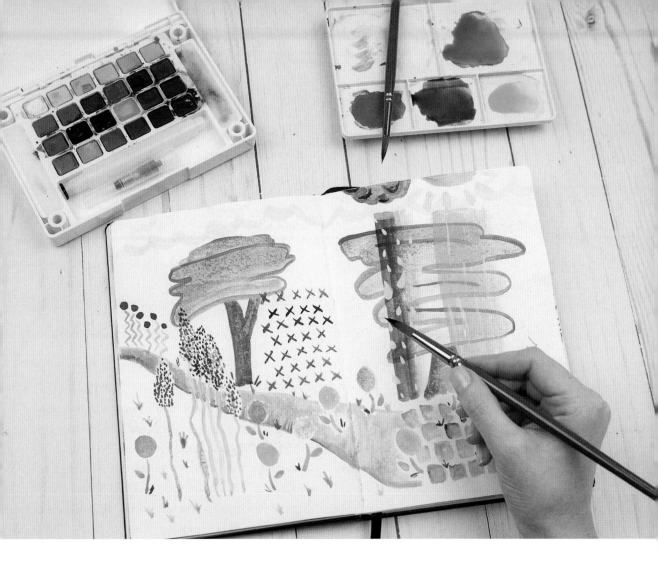

Art Journaling

Of all the styles mentioned here, art journaling is the least structured. It is defined by its use of colors, mixed media, and visual art techniques, and it does not always contain written words. If you're artistically inclined, you may enjoy the freedom this style gives you to express yourself in different ways.

Art journals range from abstract to detailed. Whether you want to capture emotions or practice drawing, keeping your artwork together in a journal makes it easy to see progress over time. It's a great way to experiment with new techniques and materials. Having a free space to try new things is especially useful for perfectionists who grieve over mistakes and stray marks in their everyday journals (see Chapter 3 for tips on dealing with mistakes).

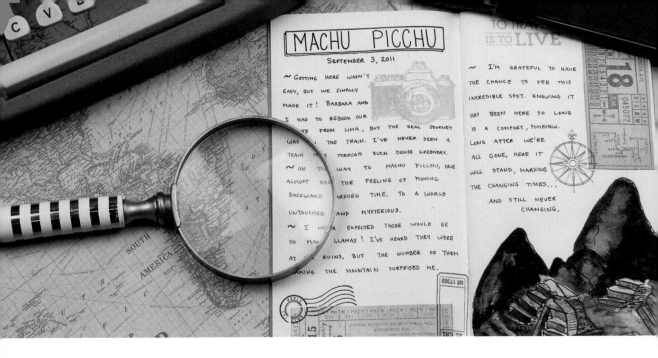

Travel Journaling

Travel journaling is favored by the jet-setters of the journaling world. As the name suggests, travel journals preserve memories of new places, exploration, and tourism; they are compact scrapbooks or field notebooks.

Travelers can preserve tickets, paper scraps, stamps, photos, and sketches of landmarks by taping or gluing them onto their pages. Many travel journals share a distinct vintage aesthetic. Ivory paper and muted colors suggest the pages have faded over time. The result is a nostalgic effect that evokes the romance of exploring unknown lands. Even those who don't travel can appreciate the style, and some have adopted a traveler aesthetic for their everyday journaling.

Planning & Journaling

Journaling and daily productivity intersect with this style. Countless iterations of notebook planning that exist today, including do-it-yourself planners, task notebooks, and the many types of calendar-notebook combos on the market, belong in this category. The most notable system for planning with a blank notebook is undoubtedly the Bullet Journal®, developed by Ryder Carroll. This book will not cover the basic order of that system because Bullet Journal has free online resources for anyone wanting to learn it. However, it is a simple, highly flexible system that mixes well with the other styles of journaling in this book. Check the Resources section on page 128 for more information.

Other people use their journals like an ordinary pre-printed planner, except they

draw each calendar page by hand, customizing each element, and adapting them from week to week. The challenge with ordinary paper planners is the limited space they devote to notetaking and list-making. Combining planning with journaling offers ultimate flexibility over formatting to manage every aspect of life.

Whether it's creative or minimal, journal planning generally turns plain notebooks into fully customized planners, complete with calendars, task lists, planning spreads, trackers, and logs. Many people use an index or table of contents to catalog important pages, which makes it possible to manage the large amount of information a journal like this can hold. The layouts are hand drawn, so they're infinitely flexible. These systems eliminate the need for special software and give users complete control over how to organize pages. If the layout doesn't work, no problem. Turn the page and

try something different. There's no need to move to an entirely new planner.

Furthermore, the aesthetic is up to you. If you gravitate toward artistic pages, you can decorate with vibrant swashes of color. Maybe clean lines and simple formats get you out of bed in the morning. Either way, you're free to put your personal touch on each page.

Now that you're acquainted with popular styles of journaling, you can pull inspiration from them as you continue on your own journaling adventures. Don't think of these categories as templates. Just keep them in the back of your mind as you move through the rest of this book. You can experiment and combine different techniques until you develop your own style and methods.

The next chapter will introduce popular tools for journaling and show how the right tools can influence your journaling practice.

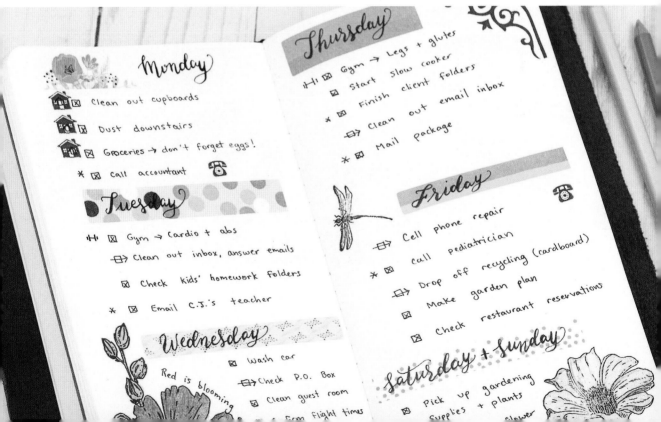

CHAPTER 2
Supplies & Tools

The most common questions I hear from new creative journalists are about supplies. In truth, supplies matter, but they aren't the be-all or end-all of any journal practice.

Journaling is inherently a low-equipment hobby. You really only need something to write with and a place for your notes. Most people already have those on hand. That being said, you may find you get more enjoyment out of the experience when you invest in high-quality supplies that go the distance over time. The last thing you need is a pen that explodes all over your schedule for the month.

People often use their journals more when they invest in good supplies. It signifies that they've made a commitment. Quality supplies also create a sense of luxury in an otherwise ordinary experience. It feels great to pull rich ink across smooth paper. Most office supply stores and booksellers will stock basic supplies to get you started. If you want more specialized notebooks (like ones with fountain

pen–friendly paper or a specific paper type), consider shopping at online stationery supply stores such as:

- Jet Pens (jetpens.com)
- Goulet Pens (gouletpens.com)
- JB Welly (jbwelly.com)
- Jenni Bick Custom Journals (jennibick.com)
- Two Hands Paperie (twohandspaperie.com)
- Etsy.com: Individual shops specialize in handmade journals, inserts, stamps, and stickers.

The point of this section is not to dictate the *best* markers or notebooks. However, the options below emerge repeatedly as favorites in journaling circles. The best supplies for you depend on your personal tastes, budget, journaling style, and lifestyle. Keep those factors in mind when choosing your supplies.

CHOOSING A NOTEBOOK

Let's start with the most important item: the journal itself. You can begin with any plain notebook you have on hand, but quality also matters. Treat your journal like a valued companion. You will likely commit to a notebook for months at a time, so it makes sense to choose something that can stand up to daily use.

No matter which style of journal you choose, factor in your ideal size. Many brands have their own sizes, while others follow international paper sizes. If you're unfamiliar with terms like "B5" or "A6," the chart on the next page will help you order the right size.

Notebook Size Guide				
Size	Inches	Millimeters	Size Comparison	Notes
A4	8.3 x 11.7	210 x 297	Standard letter	Copy machine paper
B5	7 x 10	176 x 250	Composition notebook	Common for academics
A5	5.8 x 8.3	148 x 210	½ standard letter	½ of A4 size
B6	5 x 7	125 x 176	Greeting Card	½ of B5
Standard (Traveler)	4.3 x 8.25	110 x 210	Tall & narrow	Notebook makers
A6	4.1 x 5.8	105 x 148	Postcard	½ of A5 size
Personal (Traveler)	3.75 x 6.75	95 x 171	Tall & narrow	Midori and other travel notebook makers
Pocket	approx. 3.5 x 5.5	89 x 140	Similar to passport*	Field notes/sizes vary
B7	3.5 x 4.8	89 x 122	Passport*	Also called "Pocket"

Biggest

Smallest

* The terms "Pocket" and "Passport" are often used interchangeably. Check measurements to be sure.

Paper Options

When I was new to journaling, I chose journals based on what the cover looked like. I still enjoy a pretty cover, but I've become pickier about paper. It's just one of my journaling quirks. Now, I select my notebooks based on paper quality and ruling. It's very easy to dress up a journal cover with stickers, vinyl decals, or paint. Paper, on the other hand, is the very heart of the notebook. Try a few different types until you find what works for you.

Consider the paper quality. Ink bleeds through porous paper and can ruin adjacent pages. Some people dislike *ghosting*, which happens when ink on one side of the paper is visible on the back side.

You can also choose a notebook based on the type of ruling you prefer: dot grid, squared, lined, or blank. Many creative journalists favor dot grid and squared, but lined paper and blank pages also make great choices.

Blank paper gives you the most flexibility without any visual distractions. Of course, that also means there aren't any lines to guide you. Lined pages are nice if you favor traditional

journaling and plan to write long paragraphs. Squared ruling on paper gives structure both vertically and horizontally. If you like building charts and graphs to track your life events, squared makes that a snap. Dot grid retains many of the benefits of a squared grid, but the dots are less conspicuous. Some people like the subtlety of dots because their artwork is more prominent. However, because the dots recede into the background, people with eyesight limitations may find them difficult to see.

NOTEBOOK STYLES

This book could not possibly cover all notebook options on the market, but there are some common options you will encounter. Most people tout their chosen system as the best. Rest assured, there is no best way to journal. Start with the option you are most drawn to and adjust from there.

Bound Notebooks

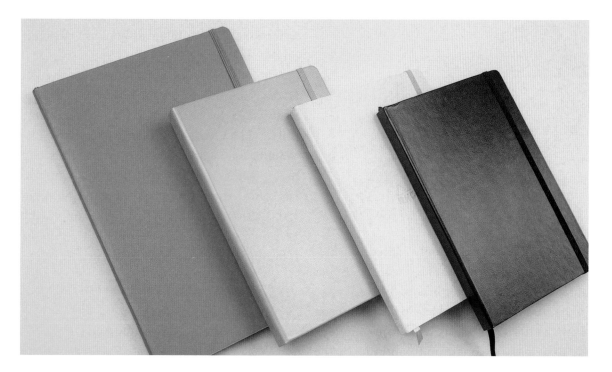

Bound notebooks are the most obvious option. They are simple, familiar, and readily available. I usually choose a hardcover notebook for my own journaling. You can use anything from a basic composition book to specialized leather journals complete with high-grade paper, ribbon markers, page numbers, and integrated pockets. The choices are endless.

Advantages of Bound Notebooks:

- Usually affordable and easy to find
- Available in a variety of sizes, paper styles, colors, softcover, and hardcover
- Pages remain securely in the notebook
- Compact and portable
- Easy to index
- Easily archived for future reference
- Easy writing experience (binding does not interfere)

Disadvantages of Bound Notebooks:

- Cannot rearrange pages by category or function
- Favorite pages do not transfer easily to a new journal
- Paper choices are limited to manufacturer options
- Not refillable

Refillable Covers with Booklets (Traveler Notebooks)

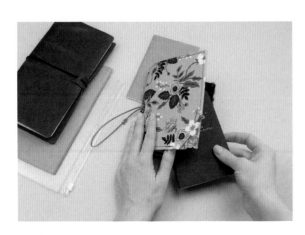

Booklet systems (commonly called traveler notebooks, travelers, or TNs) consist of an outer cover and booklet inserts. Elastic straps in the cover hold the booklets in place. You can swap out the booklets when they are complete, archive your old ones, and continue in the same cover. A booklet system offers extraordinary versatility to create your ideal system.

Don't be fooled by the name. These are popular for travel journaling, but they aren't used exclusively for that purpose. Rather, the term has evolved to describe a particular type of notebook system. The idea is to choose your cover and fill it with booklets and accessories of your choosing. Several companies offer a variety of booklets. One combination might include a datebook, a dot grid booklet for creative spreads, and a lined booklet for daily reflections. The number of booklets depends on the cover's capacity.

The tall, narrow cover pictured on the left is the standard travel journal shape, and is readymade by companies like Midori (now called The Traveler's Company), Foxy Fix, Wanderings, and many others. Covers are often leather (or vegan substitute), but you can order them online in almost any material, size, or color you desire. For example, the pocket-sized floral cover in the photo was custom-made through a shop on Etsy.com.

Advantages of Traveler Notebooks:

- Highly customizable
- Refillable with choice of booklet
- Covers withstand daily abuse of active lifestyles
- Segmenting with booklets eliminates/minimizes need for index

Disadvantages of Traveler Notebooks:

- Changing out booklets can interfere with an index system (if one is desired)
- Can be bulkier than a standard notebook
- Some people do not like having journal segmented into booklets
- Elastic closures can damage booklet pages

Ring-Bound & Disc-Bound Notebooks

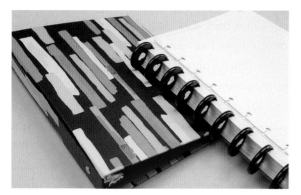

Ring-bound and disc-bound systems are well-known in the planner world. Many people choose 6-ring (such as Filofax), 3-ring, and disc-bound planners because they can move pages, organize by section, create dividers, and refill with their favorite paper.

People who are reluctant to give up a traditional planner might need a clear division between journal pages and scheduling. With rings or disc-bound options, it is possible to split the binder into planner and journal sections without having to carry separate books.

Binder systems afford users the ability to reorganize individual pages. This also eliminates the need to recopy favorite pages when it is time to move to a new journal.

Advantages of Ring-bound and Disc-bound Notebooks:

- Can customize all aspects: tabs, paper, printable layouts, sections for planning and journaling, etc.
- Choose any paper or print your own premade layouts
- No need to recopy a collection or list to a new journal

Disadvantages of Ring-Bound and Disc-Bound Notebooks

- May require a specialized hole punch for paper and off-brand inserts
- Rings and discs can make writing uncomfortable
- Bulkier than basic notebooks
- Discs and rings may tear through paper edges, resulting in lost pages

That's enough to give you a place to start. Selecting and preparing a new journal is a wonderful process, and half the fun is in the search. Spend a little time exploring online and in your local shops, then start with what makes sense to you. If your first choice does not live up to expectations, switch things up next time.

WRITING INSTRUMENTS

So, you've found the right notebook to take on your journaling adventure. The next thing you'll absolutely need is something to write with.

Pencil is a great option, one that is probably underrated in the journaling community.

Graphite smears easily, but it is also casual, simple, and erasable. Mistakes are not something to fear in creative journaling (more on that later), but if you struggle with perfectionism, pencil can help you relax.

Everyday Writing & Drawing Pens

Any pen will work for journaling. There are, however, a few options that continually rise to the top as favorites.

Fine felt-tipped pens are quite popular for drawing and everyday writing. They range from office quality to fine art (with archival inks and cleaner tips). With different tip sizes, the lines these pens produce can be anywhere from bold to needle thin. Many sketch artists create pen and ink drawings with felt-tipped artist pens because the ink is intensely dark, yielding maximum impact on a white page. Simple doodles on a journal page will pack a big punch with these pens.

Gel pens create a smooth writing experience and dark line, and they are easy to find at most stores. Left-handed users may experience more smearing with gel pens than with ballpoint or felt-tipped pens.

Fountain pens are a great choice for people who enjoy writing longer journal entries. Since they require minimal pressure to write, they reduce hand fatigue. However, there is a bit of a learning curve with fountain pens and they cost more than other options on the market.

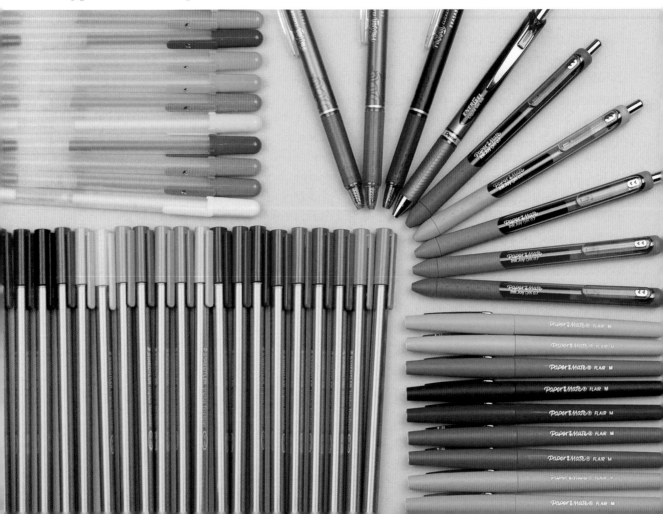

Ballpoint pen (Medium) _____ *eeeeee*

Liquid gel ink (Medium) _____ *eeeeee*

Felt-tipped pen (Medium) _____ *eeeeee*

Felt-tipped pen (Fine) _____ *eeeeee*

Archival artist pen (.005) _____ *eeeeee*

Archival artist pen (.01) _____ *eeeeee*

Archival artist pen (.05) _____ *eeeeee*

Firm Brush Pen (small) _____ *eeeeee*

Soft Brush Pen (small) _____ *eeeeee*

Colored Brush Pen (large) _____ *eeeeee*

Colored felt-tipped pen (Medium) _____ *eeeeee*

Colored felt-tipped pen (Fine) _____ *eeeeee*

Colored gel pen (Medium) _____ *eeeeee*

Erasable gel pen (Medium) _____

Opaque gel pen (Medium) _____ *eeeeee*

Colored Pens

There's a distinctive beauty in the pure black-and-white journal. If that's your chosen style, you can certainly stick with a single pen. Still, color is a wonderful addition to code tasks or create vibrant spreads that practically pop off the page. All of the pen options listed above are available in a spectrum of colors.

A word of caution: Switching pens ten or twenty times to create a single journal page can be overwhelming. Begin with a few colors at a time and add more as you become comfortable. Also, if you are going to make color an integral part of your planning system (for example, if you *only* write appointments in red ink), make sure you have a good way to transport your extra pens when you leave the house.

Once you grow accustomed to adding color to your pages, the visual beauty will encourage you return to your journal again and again. The pages can begin to feel like a second home. Designing a beautiful space encourages you to hang out for a while.

DECORATIVE SUPPLIES

Beyond pen and paper, there are a few artistic supplies that make creative journaling, well, creative! Decorative supplies are not essential, by any measure, but you may enjoy putting artistic energy into your journal.

Brush Pens

Calligraphers and hand lettering artists use brush pens to create stunning word art. Creative journal users can employ some basic lettering techniques to create artistic headers and borders.

Brush pens are available in different styles and sizes; the right choice depends on the aesthetic you want to achieve. Beginners tend to prefer brush marker pens, as opposed to pens that have an actual paintbrush at the end.

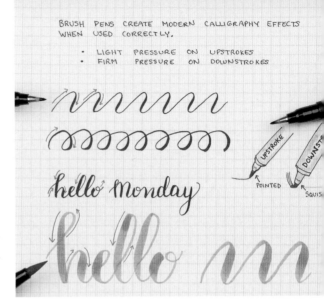

Watercolors & Colored Pencils

Watercolors and colored pencils offer a different visual effect from colored inks. Some journals take watercolor better than others, so it is wise to test a small area before going wild with a wet brush.

Colored pencil is especially handy for shading large areas or adding subtle touches of color. One argument against colored pencils is, like graphite pencils, they can smear onto adjacent pages. Still, they provide greater control over blending colors and overall saturation level.

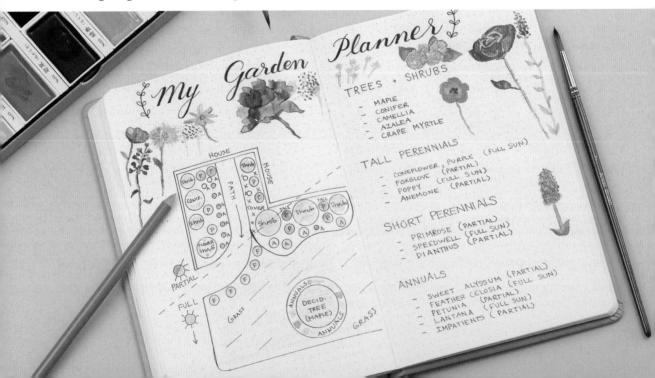

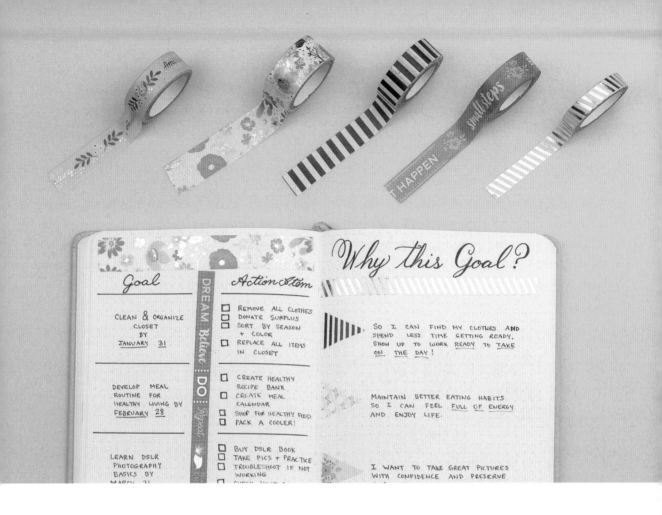

Washi Tape & Stickers

Even if you are not a doodler, you can add color and artistry to your journal with washi tape and stickers. Washi tape is similar to masking tape, but it comes in countless patterns and colors. In strips, it creates borders or dividers. Use it to cover mistakes, add color to the top and bottom of a page, or cut your own stickers. Some people even label their page edges with tape (or colored stickers) by assigning different tape patterns to each category (home, healthy, personal, etc.).

Stickers are also a handy way to add energy and color to your routine. You can instantly brighten a page (and your day) with your favorite stickers. Paper planner brands make stickers specifically to fit their planners, but these also convert well for journal spreads.

Stamps & Stencils

Adding artwork with stamps is a familiar technique for most paper arts. Thanks to the popularity of paper planning, people looking to merge scheduling with creative journaling have a host of tools to choose from. Stamps and stencils make it easy to add icons, checklists, and other small embellishments. Some Etsy shops even sell specialized stencils for drawing calendars and other planning layouts in various journal sizes.

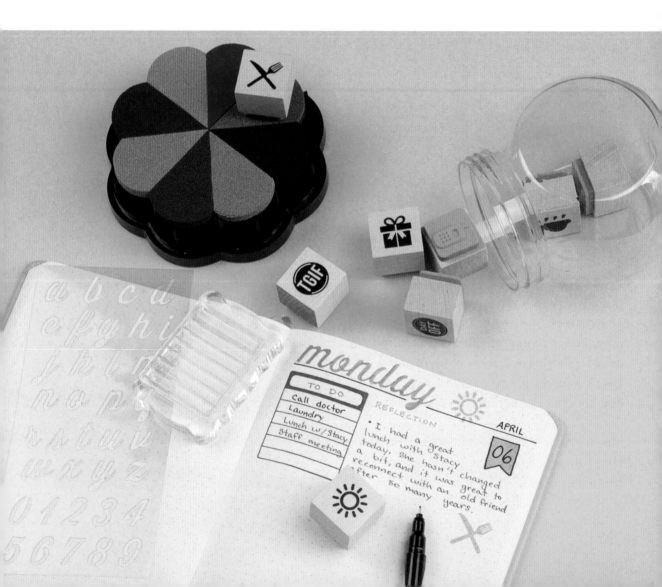

GADGETS & EXTRAS

Some pages are more complicated than others. These tools are not at all essential, but they make life a little easier. Decide for yourself how many supplies you can tolerate.

Ruler & Compass

A straight edge or small ruler can be especially handy for sectioning off planning pages, calendars, and dividing pages. If your notebook has a pocket in the back, you can use it to store flat items, like a ruler and compass. Then you only have to grab your notebook and a pen, and you can journal wherever life takes you.

A compass also comes in handy for circular diagrams. If you don't like a compass that pierces your journal pages, try a circle-helix stencil, like the one shown in the photo. The outer edges remain in place as the inner part

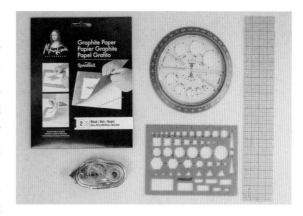

swivels. It is a great tool for creating spreads with nested circles, Venn diagrams, wheels, or onion diagrams.

Adhesive & Graphite Paper

Paper adhesive is ideal for pasting detailed images or graphics into your journal. Some people enjoy adding photos, memory scraps, and detailed images. Pasting directly into your journal eliminates guesswork with diagrams or maps, especially since they are difficult to draw by hand with any accuracy. Your local hobby supply store will have different types of tape and glue available.

Brands like Tombow and Scotch make permanent adhesive tapes. These generally come in a roll applicator, and the adhesive holds paper firmly in place without any dry time. Unlike liquid glue, roller adhesives won't leak

or explode, making them ideal for traveling. As for glue, choose something that is specifically made for paper crafts, scrapbooking, or photo albums. They're often advertised as "acid-free," "archival," or "wrinkle-free." I've also had good luck with permanent glue sticks.

If you are working with a ring-bound or disc-bound notebook, adhesives aren't necessary. You can use a hole punch to add whatever pages you need. Keep in mind that every page you add to your journal increases its bulk. Graphite paper allows you to trace images directly onto your notebook's existing pages. Chapter 3 covers this technique in more detail.

Key

BULLETS

- TASK
- o SUB-TASK
- △ EVENT
- — NOTE

{ STATUS }

- ✗ COMPLETED
- ↙ STARTED
- ➡ LATER
- ~~CANCEL~~

✱ ICONS (OPTIONAL) ✱

- PHONE CALL
- RESEARCH
- PRIORITY
- URGENT
- QUOTE / MOTIVATION
- EXERCISE
- IDEA
- QUESTION / UNSURE

COLORS

- HOME
- KIDS
- WORK
- PERSONAL
- HEALTH
- PROJECTS

CHAPTER 3
Tips & Tricks

This chapter will cover techniques for maintaining order in your journal, as well as a few solutions to common problems. Creative journaling offers the ultimate freedom, but it also makes the user responsible for design and organizing. Maybe you've experienced one (or all) of these situations:

- "I can't find the page I need!"
- "My creative spreads get lost in my planning pages. How can I keep them straight?"
- "I wish I could make beautiful journal spreads, but I have *zero* artistic ability."

- "My life has so many different areas: work, family, education, my side hustle... I can't handle it all in one notebook."

If any of these sound like you, don't worry. It is not uncommon for new journal users to feel overwhelmed or frustrated at first. The good news is somebody else already had the same problem and developed a solution.

As you gain confidence, you'll develop your own methods that work for you. Until then, try the suggestions in this chapter and adjust as you see fit.

STAYING ORGANIZED

When you first open your notebook and look down at the blank page, you may feel a little lost. All that wide-open space can seem like an ocean at first. Luckily, a few simple tricks will make you a master of your notes and goals.

Map Out First Pages (Sticky Notes)

Before you write anything in your journal, take some time to consider your intentions. The front of your notebook is a prime location for important or frequently used pages. Give them some thought.

Some people want their scheduling pages up front where they can access them quickly. Others prefer to work through the journal, creating monthly logs as the need arises. Goal-oriented people like their goals right up front. Creative types might want an inspiring illustration. It is completely up to you.

Here's one possible order for opening pages:

1. Table of contents (index)
2. Fun doodle page to set the stage
3. Dates to remember (holidays and birthdays)
4. Long-term (annual) planning pages
5. Important addresses
6. My planning routine

Try marking your first few pages with sticky notes as a practice run. As you flip through, you'll be able to visualize the initial flow of your journal and move your sticky notes around. Once you're happy with the order, write out your pages. This technique can also relieve first-page jitters as you break in a new notebook.

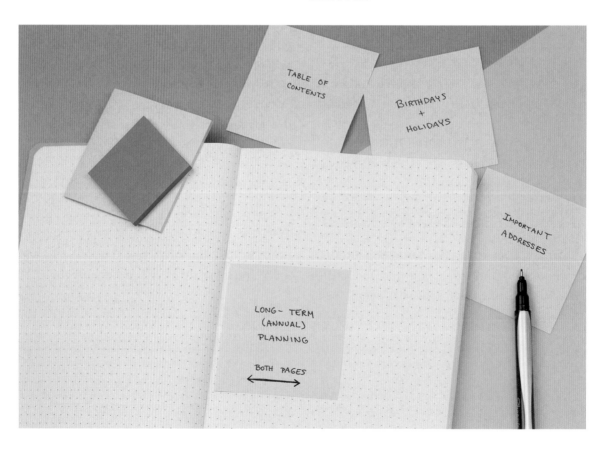

Keep an Index

An index or table of contents is one of the simplest ways to find your pages quickly. This works best in bound notebook systems where the pages aren't moved. If your notebook doesn't have an area for indexing (some journals come with one already printed), you can save two to three pages in the front or back of your notebook for this purpose.

Instead of listing every page in your table of contents, save space (and time) by listing important or unique spreads. Try setting times in your routine to update the index, or make it part of a planning checklist. It may not be

the most exciting part of journaling, but don't underestimate its power. Many people skip over this step only to discover it could have saved them time and frustration.

Use Separate Booklets or Sections

Indexing is great for finding anything and everything in your journal, but what if you like grouping similar pages together? If you use a refillable notebook, you can segment it to avoid keeping an enormous amount of information in the same place. In school, you probably had separate notebooks for each subject. Dividing your life into categories can make it easier to focus on one thing at a time.

In a traveler notebook, for example, you can assign separate booklets for scheduling, school or work, lists, collections, trips, special projects, and so on. Since all booklets are held together in the same notebook cover, you still get the convenience of an all-in-one notebook. Dividers, tabs, or booklets be used for the same effect in a binder or disc-bound system.

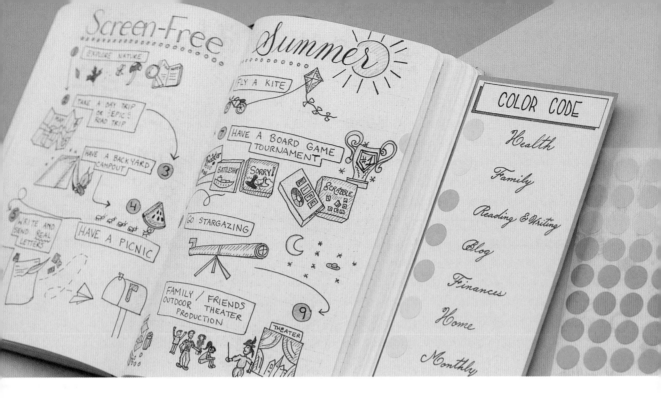

Categorizing Pages (Labels)

This is one of my favorite methods for locating information in my journal. Let's suppose you want to find all the pages dealing with health and fitness. In a standard bound notebook, rearranging pages is not an option, but you can still create categories that let you group pages *visually*. Here's how it works:

- Create a color code and attach it to the back cover of your notebook. It will act as a guide for where to place each color on your pages.
- Fold a colored sticker over the edge of the page you want to categorize, keeping it lined up with the same color on the guide.
- When you want to find all of the pages in a given category, you can fan through the journal to spot them quickly. You can assign the page to more than one category if needed.

Colored markers or pens also work instead of stickers. For that matter, you could flag the pages with different washi tape patterns. The function is the same. The goal is to break the journal into categories, but the physical pages stay in place, so there's no need to make corrections to the index. It is a very intuitive technique once you get it set up.

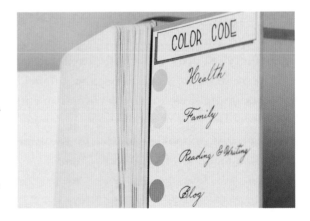

OTHER TIPS & HACKS

Now that your general organizational needs are addressed, here are some other useful tips to keep in mind. These tips won't make or break your journaling life, but they can make things a bit easier.

Pencil & Graphite Paper

I've had people stop me in public to ask about my journal. Almost always, the conversation turns to, "I wish I could keep a journal like that, but I have *zero* artistic talent."

Let's clear this up right now: Creative journaling requires no artistic talent. Not even a little. Zero.

First of all, you don't ever have to add artistic elements to your journal unless you want to. Second, you can cheat. Either take your time to outline things in pencil, or transfer images with graphite paper for your own personal use.

Graphite paper is sold near the sketching supplies at your local art store. As its name suggests, it is coated on one side with graphite so that an image laid on top of it can be traced onto a surface. Don't confuse graphite paper with tracing paper. Tracing paper is translucent and lacks the necessary graphite coating to make this process work.

You can print and trace anything you want into your journal: maps, graphics, or headers

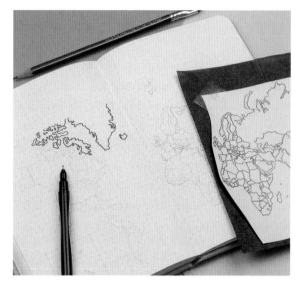

in your favorite font (just be respectful of any copyrights that apply to your chosen image). Place the graphite paper on your journal page (dark side down). Lay your printed image over it. Without moving the printed image or graphite paper, trace the parts of the image you want in your journal. To finish, go over everything again in ink and erase any stray graphite marks.

Working from Both Ends

If you want to keep certain types of pages separate, you can actually work from both ends of the notebook. For instance, if you wanted to keep planning pages separate from collections or lists, you could start them on opposite ends of the journal.

With this approach, you might also try two indexes and two separate page numbering systems for your journal:

- Index 1 tracks planning pages. They begin on page 1 and move toward the back cover (forward in the journal).
- Index 2 tracks collections and lists. These begin on the last page of the notebook (I've numbered my example with a "C" to indicate they are collection pages), and they work toward the front cover (backward in the journal).
- The sections meet in the middle when you run out of pages.

Note: If your journal already has numbered pages, you can still use this approach. Your first index would have ascending page numbers beginning with 1, and the second index would have descending page numbers, beginning with the highest page number.

Here's why you might choose to do this: If you tried to divide your notebook into predetermined sections, you would need to estimate how many pages to devote to each section. That's no easy task, and you'll likely run out of pages in one section before the other is filled. Working from front and back simultaneously ensures you use the correct number of pages for each section.

Keys & Flip-Out Guides

Creating a key somewhere in your journal helps with consistency. You'd be surprised how often you can forget the meaning of your own symbols. Some people like a very simple system to indicate tasks or appointments. Other people like different shaped bullet points, icons, and color-coded inks. Either way, you can put the key in a page of your journal or on a card that flips out from the cover.

A flip-out card is handy because you can see it while writing on another page your journal. These are very easy to make. Simply tape the card to the edge of your notebook cover. It

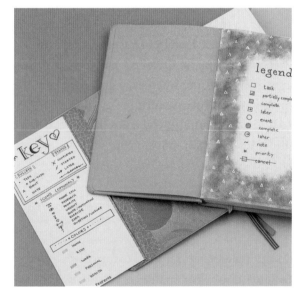

folds into the cover when you are not using it. The color-coding guide for page labels (mentioned earlier in the chapter) is another use for flip-out cards.

DEALING WITH MISTAKES

Mistakes are inevitable. Give yourself permission to make mistakes, and realize they are only ink marks. The best ways to deal with mistakes are to correct them or roll with them.

You can cover a mistake with white correction tape, washi tape, stickers, printable coloring sheets, or photos. It gives you something attractive to look at instead of dwelling on your own mistakes.

Another approach is to roll with the mistake. Embrace it. Laugh a little, doodle around it, and turn it into a private joke. No one is perfect, so there is really no reason to aspire to perfect journal pages. Journaling is much more enjoyable when you let loose a little.

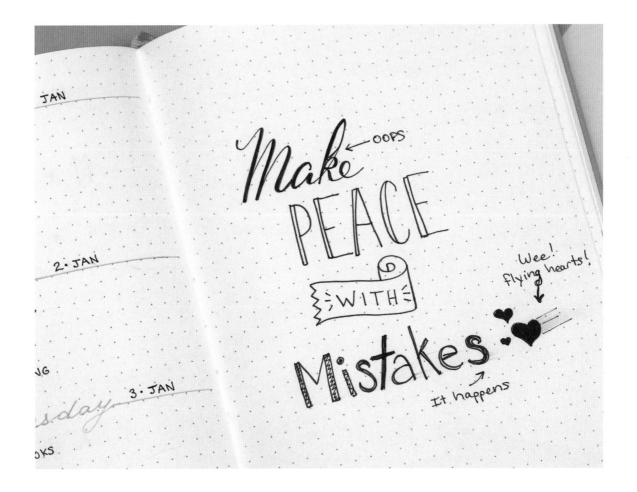

journal checklist

Annual Core setup (OR NEW JOURNAL)
- CREATE YEARLY PLANNING PAGES
- SET ANNUAL GOALS
- MOVE PAGES FROM OLD JOURNAL
- CREATE ANNUAL TRACKERS

Monthly Core Pages Setup

- CREATE MONTHLY SPREAD
- ADD MONTHLY TRACKERS
- CHECK BIRTHDAYS + HOLIDAYS
- CHECK YEARLY SCHEDULE
- CLOSE OUT PREV. MONTH
- UPDATE INDEX
- MOVE UNFINISHED TASKS
- SET GOALS

	1	2	3	4	5	6	7	8	9	10	11	12
	J	F	M	A	M	J	J	A	S	O	N	D

Weekly and Daily
- CHECK APPOINTMENTS
- MARK OFF ___ TASKS
- ELIMINA___ ___ANT TASKS
- MAKE ___ ___ IF NEEDED
- MAKE ___ ___ NEEDED.

GOALS

TASKS FROM LAST WEEK.

FOR NEXT DAY
___ENTS + PRIORITIZE TASKS.

TRACKERS + COLLECTIONS AS NEEDED
T IS WORKING AND.
___OT.

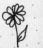

CHAPTER 4
Building a Foundation

Creative journals tend to fall somewhere between scrapbooks and planners. Printed planners come with a ready-made structure. Each day has a specific amount of space allocated to it, and all you have to do is drop your tasks into the right space. Not so with a plain notebook. Creative journaling gives you more freedom to express yourself on custom pages, but you also need to consider how you'll stay organized in all that blank space. This is where you'll benefit from a routine.

As humans, we thrive on routine. It gives our days a sense of security and predictability, and makes us more efficient at everyday tasks. The more we do something, the easier it becomes. Every now and then, we pick a new activity to add interest and adventure to the mix. The same can be said for a journaling routine.

Your core pages will begin to form a pattern over time. Some pages will be needed once a year, while others will repeat monthly, weekly, when the seasons change, every time you go for a run, and so on. Your lifestyle and goals will drive which pages form your foundation.

It's a good idea to plan a set of core pages from the beginning of your journal. If you find you prefer less structure, you can always loosen up your system. Just turn to the next blank page and start over. Establishing a system is more difficult than letting one go. As your life changes, you can always adjust your system to match.

Unlike printed planners, having a solid journaling foundation does not mean you'll be stifled by layouts that do not meet all of your needs. You can enjoy the benefits of structure while preserving the joys of expression and spontaneity.

CORE PAGES

There are certain pages you will create or reference regularly. These become the core of your journaling system, the central framework from which all other pages flow. For some people, scheduling is central. Others may be more interested in documenting memories, reflections, and health goals. Try to pinpoint your primary motivation for keeping a journal so you can focus your energy on the right pages.

Don't try to copy anything into your journal ahead of time, though. These are your bread-and-butter pages, but you only create them in your journal when they're needed (and not before). Working ahead in your journal can create problems. Picture when you will create these pages in your journal and how often you will reference them. You may want to make a list of your core pages to get a feel for how they work together. For example, each month, you might create a monthly finance tracker immediately following your monthly calendar page.

Remember, you're not putting these pages in your notebook ahead of time. Core pages are simply the ones you predict you'll use most. A simple approach is to follow time intervals. This is a very natural way to organize a journal because it matches calendar units (days, weeks, months, etc.). We're accustomed to thinking about our lives in these time blocks.

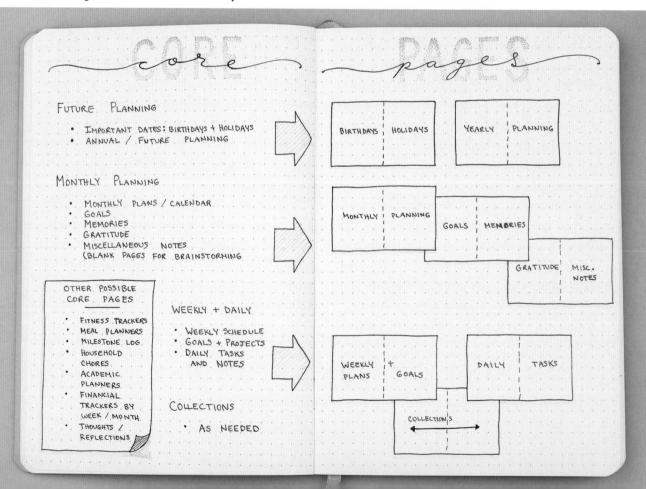

Simple Core Pages:

- Yearly (long-term) scheduling
- Monthly planning
- Weekly planning
- Daily task lists
- Creative pages and lists as needed

Another approach is to move beyond simple scheduling. If preserving memories and tracking goals matters to you, your core system might include a few pages for those goals. The resulting system is a bit more robust but still allows for flexibility.

More Complex Core System:

- Birthdays and holidays
- Yearly calendar
- Quarterly "big picture"
- Monthly scheduling
- Books I'm reading this month

- Monthly health and fitness tracker
- Monthly memories
- Daily task lists
- Daily reflections
- Creative pages and lists as needed

Those are just two examples, but the possibilities are endless. Your ideal core system may look completely different. Feel free to play around with it along the way.

No matter how basic or complex any core system is, notetaking and unexpected needs will arise. You're free to make pages whenever you need them: lists, collections, doodle spreads, and memory pages. Regular core pages (or semi-regular) simply act as reference points for planning, reflections, and indexing. With your framework in place, you'll have an easier time keeping regular journaling habits.

DEVELOPING YOUR PLANNING RHYTHM

Your core pages will help to establish a rhythm or cadence to your journaling routine. Everyone's rhythm will be slightly different, but it is safe to assume yours will include some pages on an annual, monthly, weekly, or daily basis.

If you have a hard time picturing how to keep track of everything, it might help to identify how a project or task will flow through your journal. You can also write down your planning routine to keep you on track. Your project flow and routine are interdependent, but for clarity, this chapter breaks them up.

Planning or Project Flow

Some entries in your journal will be one-time pages: "Book to Read" or "My Summer Road Trip" are fun pages that fill a purpose, but they probably won't repeat frequently enough to become staples in your system.

A big project, on the other hand, can be so complex it has to be divided over time. Large undertakings can seem daunting at first, but as you break out the individual parts, they trickle down through monthly, weekly, and daily pages, becoming specific actionable tasks.

The process happens naturally as you move projects from broad long-term spreads to more specific short-term spreads, but it helps to be aware of it. The same order applies to single tasks that are simply migrated from one page to another (unaccomplished tasks that get moved from one day to another, for example).

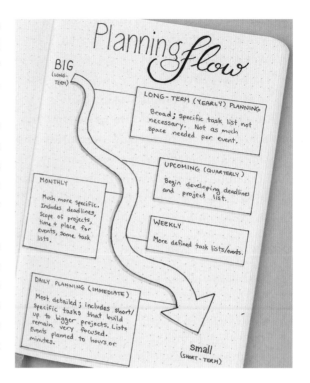

Formalizing a Journaling Routine

Another useful way to establish a rhythm is to formalize your routine. Carving out regular times to sit down with your notebook is a great way to solidify your journaling practice. Eventually, it will become second nature for you to flip open your notebook and jot down an idea.

A well-planned journaling routine also gives you natural cues for turning those ideas into actions. The hardest part is getting started. Begin by writing out your plan, including set times to create those all-important core pages. You'll notice natural transition times for creating each page in your journal. A weekend, for example, is a good time to prepare for the upcoming week.

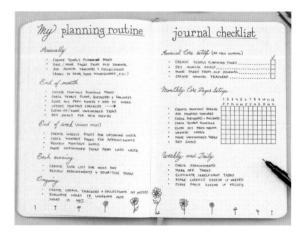

Sample Journaling Routine:

- **Annually**
 - *Create long-term (yearly) planning pages*
 - *Save or move pages from old journal*
 - *Add annual trackers and collections (Books to Read, Home Maintenance, etc.)*
- **End of the month**
 - *Create monthly planning pages*
 - *Check long-term (yearly) planning, birthdays and holidays*
 - *Close out previous month and add to index*
 - *Update monthly checklist (if using)*
 - *Clean up/reschedule unfinished tasks*
 - *Set goals for new month*
- **End of the week**
 - *Create weekly planning pages for upcoming week*
 - *Check monthly pages for appointments*
 - *Review monthly goals*
 - *Move/reschedule unfinished tasks from last week*
- **Each evening**
 - *Create task list for next day*
 - *Review appointments and prioritize tasks*
- **Ongoing**
 - *Create useful trackers and collections as needed*
 - *Evaluate what works and what does not*

You should also take into account your personality and habits. If you are a morning person, you may benefit from scratching out some thoughts right after you wake. This can help you focus and visualize your day before the distractions begin. Some people prefer to journal in the evening, carefully prioritizing each task for the next day. Hobby journalists,

in particular, seem to enjoy working in the evening. They can relax by doodling and coloring as they watch television, copy inspirational quotes, and plan tasks for the next day.

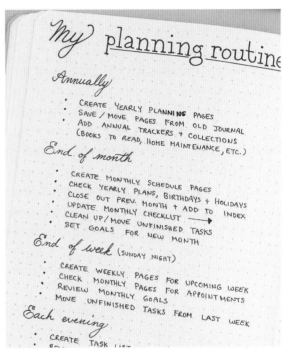

Once you have a better idea of when you'll create each page in your journal, you can visualize how this routine will work with your planning flow. Sometimes, you'll have to move tasks from a long-term page to monthly or weekly pages. Tasks are most likely to be lost or overlooked when they're moved between pages, so having a checklist can keep you on track.

I still use a checklist each time I create a new monthly planning page. It is the easiest way I've found to stay organized and minimize lost bullets, notes, and appointments. This is just one example of how you might ensure you haven't forgotten anything in the move to a new monthly page.

After Creating a New Monthly Page:

- Check long-term plans/school/work schedule and add to monthly spread
- Check birthdays and holidays and write them on monthly spread
- Check annual goals and break into smaller goals for the month

A journal routine checklist can be its own page (like the one to the right), or you can incorporate those tasks into a larger habit tracker (see photo below). There are some advantages to keeping all habits and recurring tasks in once place, but it takes a bit more thought. Consider keeping simple trackers at first. Over time, you'll get a better sense of which tasks need their own checklist and which can be lumped together into one big chart. Chapter 5 discusses habit trackers and charts in more detail.

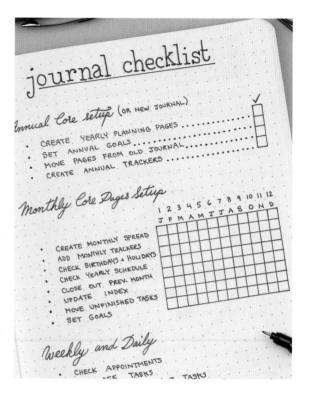

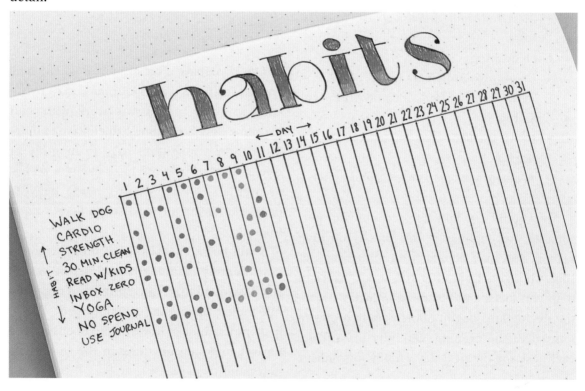

DEALING WITH SETBACKS

No matter how intentional you are about your journaling practices, like everyone, you will deal with setbacks along the way. What matters is knowing how to deal with them. Fortunately, most problems in a journal can be fixed by turning the page. This section will cover a few of the most common journaling pitfalls and how to deal with them.

One of the main attractions with this style of planning is the ability to create custom layouts. Journal enthusiasts take great pride in their layouts and share them with glee in journaling circles. But sometimes, you may try a new layout (with high hopes) and it doesn't stand up to real life.

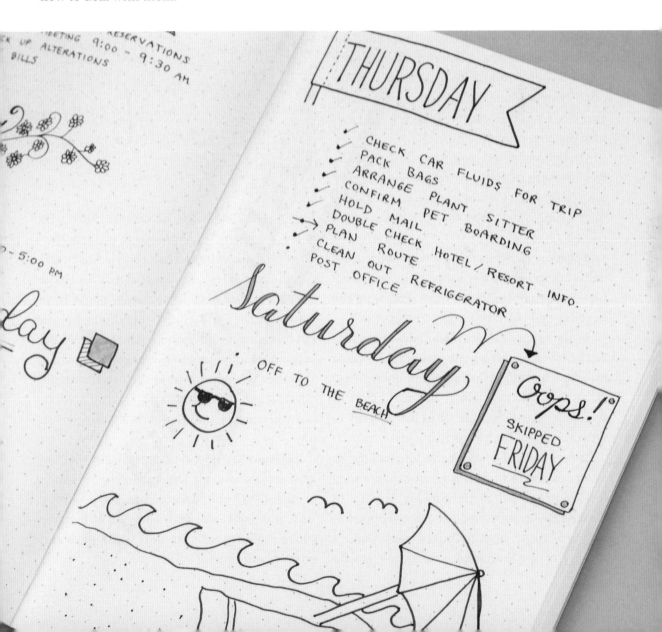

Here's an example from my own journaling experience: After a few months of simple daily checklists, I decided to move to a weekly layout with columns for each day of the week. Despite my enthusiasm for the new design, it was a disaster. The layout was beautiful. It was well-organized. It simply didn't work for me. By Monday afternoon, I had abandoned the page and started over with my old setup. It was simple to fix, though. I just turned the page and started over. After a few more attempts, I landed on a new weekly layout that suited my needs quite well. You will eventually deal with a bad layout. It might even be a great fit for other people. Don't feel discouraged if someone else's setup does not work for you; just turn the page and move on.

On that same note, some new journal users feel pressure to write every day, even if they have nothing real to put in the journal. If they miss a single day, they feel like the week is ruined. Granted, a journal (or any planner, for that matter) is more effective when you use it daily, but missing a day is not a huge catastrophe. Sometimes, you just forget. Pick it up the next day and you'll be back on track.

What happens if one missed day turns into two? It stretches to a week, two weeks, even a month. That might happen. Sometimes, you won't feel like journaling, but the pages of your journal will be there when you're ready to return to them. Nothing is really lost.

When someone abandons journaling for a long period of time, it is often because they feel overwhelmed by the process. Instead of treating this as a failure, take it as an opportunity to evaluate what prompted you to take a break. Creative journaling attracts people who

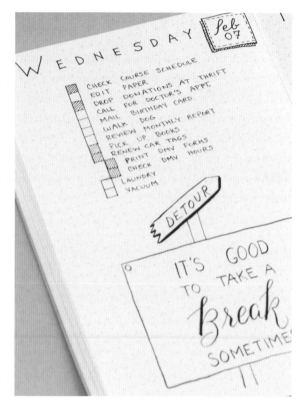

crave artistic elements, as well as those who enjoy simplicity. Examine your own motivations. Perhaps your journaling style was overly complicated. Try stripping down to basic headers and remove unnecessary pages from your routine. On the other hand, maybe you felt burdened by all those task lists. If that's the case, focus on your creative pages for a while. Whether you are drawn to the organizational attributes of journaling or the creative process, put your energy into the parts that bring you joy.

Setbacks are bound to happen, but they are just hiccups, after all. Unlike a printed planner, no pages are lost by taking a break in a journal. Your notebook will wait for you. Whenever you're ready, turn to the next blank page and unleash your imagination.

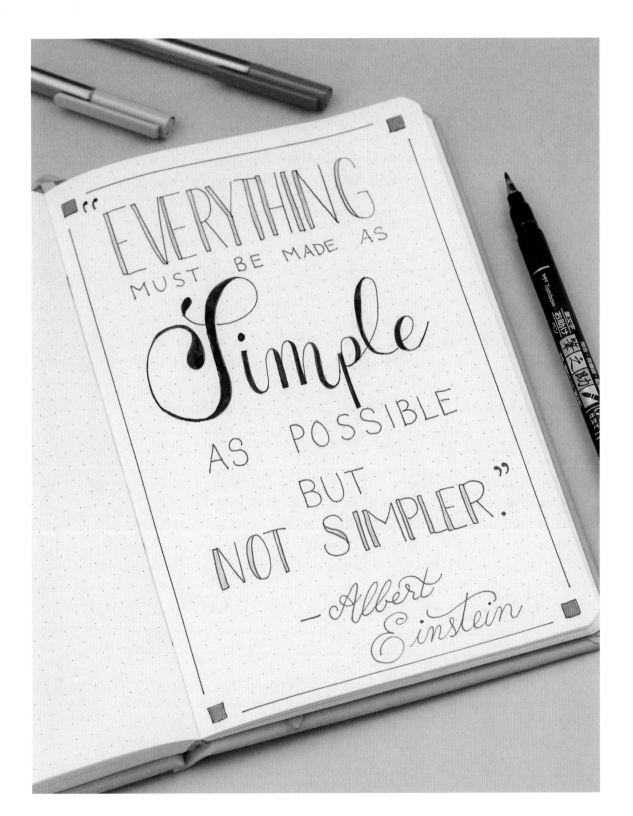

"EVERYTHING MUST BE MADE AS *Simple* AS POSSIBLE BUT NOT SIMPLER."

— Albert Einstein

jan.

S	M	T	W	T	F	S	
		1	2	3	4	5	6
7	8	9	10	11	12	13	
14	15	16	17	18	19	20	
21	22	23	24	25	26	27	
28	29	30	31				

feb.

S	M	T	W	T	F	S
				1	2	3
4	5	6	7	8	9	10
11	12	13	14	15	16	17
18	19	20	21	22	23	24
25	26	27	28			

mar.

S	M	T	W	T	F	S
				1	2	3
4	5	6	7	8	9	10
11	12	13	14	15	16	17
18	19	20	21	22	23	24
25	26	27	28	29	30	31

apr.

S	M	T	W	T	F	S
1	2	3	4	5	6	7
8	9	10	11	12	13	14
15	16	17	18	19	20	21
22	23	24	25	26	27	28
29	30					

may

S	M	T	W	T	F	S
		1	2	3	4	5
6	7	8	9	10	11	12
13	14	15	16	17	18	19
20	21	22	23	24	25	26
27	28	29	30	31		

jun.

S	M	T	W	T	F	S
					1	2
3	4	5	6	7	8	9
10	11	12	13	14	15	16
17	18	19	20	21	22	23
24	25	26	27	28	29	30

jul.

S	M	T	W	T	F	S
1	2	3	4	5	6	7
8	9	10	11	12	13	14
15	16	17	18	19	20	21
22	23	24	25	26	27	28
29	30	31				

aug.

S	M	T	W	T	F	S
			1	2	3	4
5	6	7	8	9	10	11
12	13	14	15	16	17	18
19	20	21	22	23	24	25
26	27	28	29	30	31	

sep.

S	M	T	W	T	F	S
						1
2	3	4	5	6	7	8
9	10	11	12	13	14	15
16	17	18	19	20	21	22
23	24	25	26	27	28	29
30						

oct.

S	M	T	W	T	F	S
	1	2	3	4	5	6
7	8	9	10	11	12	13
14	15	16	17	18	19	20
21	22	23	24	25	26	27
28	29	30	31			

nov.

S	M	T	W	T	F	S
				1	2	3
4	5	6	7	8	9	10
11	12	13	14	15	16	17
18	19	20	21	22	23	24
25	26	27	28	29	30	

dec.

S	M	T	W	T	F	S
						1
2	3	4	5	6	7	8
9	10	11	12	13	14	15
16	17	18	19	20	21	22
23	24	25	26	27	28	29
30	31					

- 2 0 1 8 -

CHAPTER 5
Planning Pages & Templates

You already know that your journal can be much more than a place to write end-of-the-day thoughts. If you want to turn your journal into an all-in-one life planning tool, you'll probably need to come up with a scheduling system. This chapter covers some basic page layouts for organizing your schedule from scratch.

The sample templates are grouped into Long-Term Planning, Monthly Planning, Weekly Planning, and Daily Planning categories, as well as a section for different tables and charts for tracking various life events. If we compare planning to a camera lens, you can imagine zooming in on more details as you take a project from plans to action. Long-Term Planning → Monthly Planning → Weekly Planning →

Daily Planning & To-Do Lists. Charts or tables take visual snapshots of specific aspects of life.

Many of the layouts here are shown in their bare state. It can be easier to make good planning decisions without decorations to sway the eyes. Once you have a layout that works, you can adapt and embellish it to your liking. Until then, I suggest focusing on the underlying organization and structure.

Don't feel like you have to pick a layout from each of these categories. Skip monthly planning if it's not for you. Maybe you want to combine your weekly and daily task lists. Start with the pages that best fit your needs. You can always tweak the formats as your journaling progresses throughout the year.

LONG-TERM PLANNING

Keeping a long-term planning page in your journal will give you a bird's-eye view of your life. You'll be able to see projects coming from months away. When everyone else looks around and says, "Wow, that snuck up on me," you'll already be organized with an action plan and time to spare.

This phase of planning can be fairly general. It is meant as a holding place for projects and appointments until they deserve more detailed attention.

Drop Zones

Drop Zones, as their name implies, are designated spaces to collect events and projects. Use this layout as a complete long-term planning setup or to supplement another long-term planning layout. Depending on how much space you want for each month, you can fit two, six, even twelve months on a two-page spread.

Let's pretend it is April, and you are making vacation plans with friends. You all decide to go on a road trip the second week in June. Since it's only April, you haven't made your June monthly page yet. Until then, drop the road trip in your June Drop Zone.

Since each box is an open area (no assigned spots for dates or location), you have some

flexibility in how much space you devote to each item. Maybe you don't know the exact date or location yet. That's okay. Drop a note as a placeholder and you can add more details when you move the note to your June monthly planning page.

For people whose schedules require more precision, this method might not work on its own. For example, if you need to know that November 14 falls on a Wednesday, you'll have to make some adaptation (such as adding a small calendar next to each Drop Zone). However, it could still be useful for planning individual projects throughout the year and identifying crunch points.

Disadvantages of Drop Zones:

- Tasks and events in a given month are not necessarily listed chronologically
- Does not provide a view of dates and days of the week
- Not ideal for people who need detailed planning far in advance

Advantages of Drop Zones:

- Easy to create and understand
- Can track multiple months on one page
- Flexible and broad

Column Method

This is my personal favorite long-term planning method, and it is very simple to create. The setup is a little more involved than Drop Zones, but you can still create an entire year of planning in a few short minutes.

Instead of a calendar, you will create a list of dates. Deadlines or appointments go next to their corresponding date. Place up to four months—or fewer if you like more space to write—on a two-page spread. Repeat this setup until you have a full year. Near the end of the year, you can always add additional long-term pages to extend your planning view.

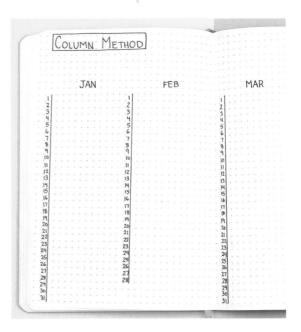

Advantages of the Column Method:

- Easy to set up and understand
- Creates a designated space for each day of the year
- Can schedule appointments long before monthly pages are created
- Allows for date and day of the week to be visible in long-term planning

Disadvantages of the Column Method:

- Not as useful for people who prefer traditional calendar view
- Not as flexible for events or projects with no set date
- Limited space for writing (can accommodate one to two appointments per day)

Depending on your aesthetic tastes, you'll be able to dress this method up or down. Both journals below use the Column Method, but the artistic choices make them look very different. Again, it's the underlying structure that determines the function, not the decorations.

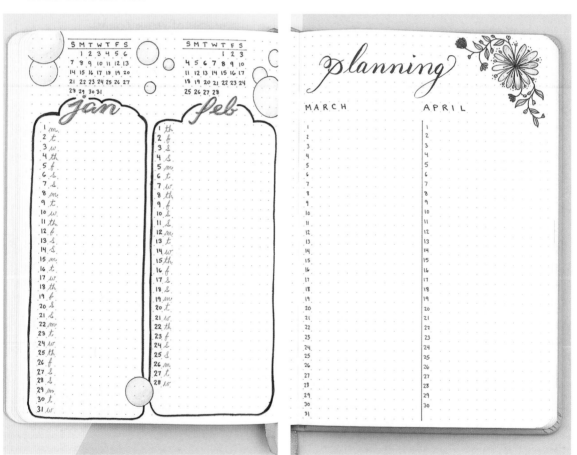

This method combines elements from the last two. Skinny Columns retain the flexibility of Drop Zones, but the layout looks similar to the Column Method.

With the journal turned vertically, divide each page into six equal columns. The long layout gives you more lines to work with (as opposed to the small boxes in Drop Zones), but there aren't any pre-filled dates.

Unless your scheduling needs are very light, this format will probably not fulfill all your long-term planning needs. I find it most useful as a supplemental planning page to track birthdays, holidays, and important recurring events each month.

Advantages of Skinny Columns:

- Entire year is visible on a two-page spread
- Easy to set up and understand
- Flexible

Disadvantages of Skinny Columns:

- Space is limited (abbreviations may be necessary)
- Not ideal for people who need detailed planning far in advance
- These pages will be rotated ninety degrees from portrait pages in the journal
- Does not provide a view of dates and days of the week

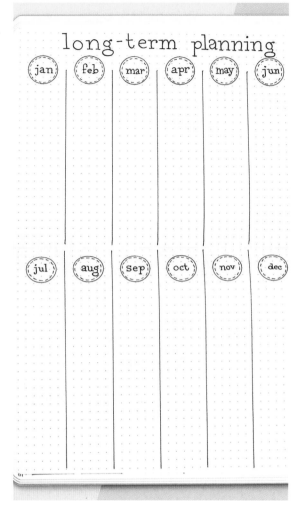

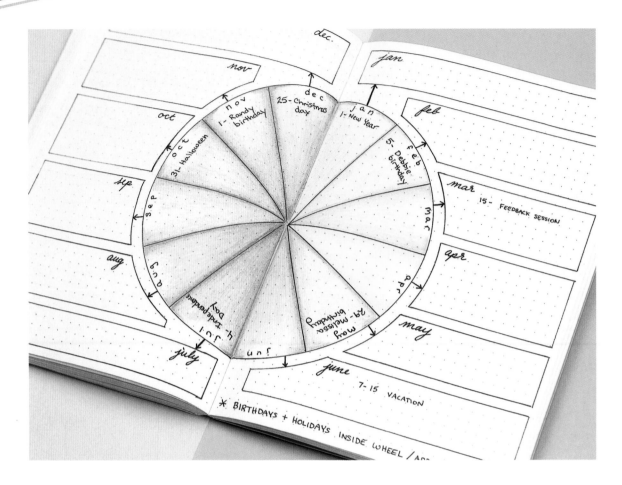

Long-Term Planning Wheel

The Planning Wheel takes a completely different approach to planning. Unlike most familiar calendars, this one uses a circular layout. This unconventional format creates a striking effect that appeals to journal users with an artistic spirit.

The example in the photo uses the colors of the rainbow to separate months visually, but this spread is just as effective in black and white. To create this layout, use a compass (a standard compass or circular helix stencil, like the one listed in Chapter 2) and section it into thirty-degree wedges. The wedges hold birthdays, holidays, and important recurring events. The boxes surrounding the wheel are for ongoing scheduling. Use these as temporary Drop Zones. They will hold events or projects until you are ready to move them to a monthly planning page or elsewhere in your journal.

This layout is a great example of how everyone plans differently. For some people, this format is too unconventional to be useful. However, others will feel it is ideal *because* it is unconventional. Give it a whirl and decide for yourself.

Advantages of the Long-Term Planning Wheel:

- The entire year is visible on a two-page spread
- Has designated space for important dates as well as Drop Zones for on-the-fly planning
- Visual elements draw the eye and encourage active planning

Disadvantages of the Long-Term Planning Wheel:

- The unconventional layout may not appeal to linear thinkers or those who prefer simplicity
- Does not provide a view of dates and days of the week
- Odd shapes can make writing more difficult
- Space is limited (abbreviations may be necessary)
- Not as simple to set up as other methods. The circular layout requires a few tools and more time to create

Stacked Monthlies

The last option this book covers for long-term planning is a method, not a specific format. Some feel that moving tasks from long-term planning to monthly spreads is too cumbersome. It is possible to write everything in the appropriate monthly page from the beginning.

Draw all twelve calendar months (or the monthly planning pages of your choosing) at the very beginning of your journal. Now, you can use premade monthlies throughout the entire year. No matter where you are in your notebook, you'll flip back to the front when you need to see your monthly schedule. You can mark the current month with a ribbon marker or paper clip to make this easier.

Advantages of Stacked Monthlies:

- No need to move events from long-term planning to subsequent pages
- Detailed planning is possible for every month of the year
- Preserves flexibility of remaining pages in the journal

Disadvantages of Stacked Monthlies:

- Monthly pages do not occur throughout the journal in chronological order.
- You'll flip back and forth in the journal a bit more
- If you create monthly memory pages, gratitude lists, or self-assessment pages throughout the year (mixed into the journal), these will be separated from your planning pages (at the front of the journal)

This is not a comprehensive list of all possible methods for long-term planning. Make adjustments to these, or experiment with your own layouts. You'll discover the precise combination that works for your unique life.

MONTHLY PLANNING

As the deadlines approach for your events and appointments, you will likely need to move them to a spread that can accommodate more details. These monthly planning layouts will help bridge the gap between big-picture planning and the specific tasks you do daily.

Life in Lists

Habitual list-makers will connect with this format right away. Plus, setup is a snap. Simply create a numbered list to represent the dates of the month. Optionally, you can add the days of the week next to the dates.

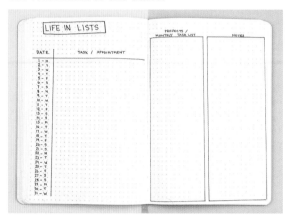

Advantages of Life in Lists:

- Creates designated space for each day's appointments or top priorities
- Additional columns can section each day by time or function (a.m./p.m., Work/ Home, etc.)
- The right page is customizable: task lists, notes, habit trackers, etc.

Disadvantages of Life in Lists:

- Very linear. May not work as well for visual thinkers
- Limited space for appointment details (may need to refer to another page of the journal for further information)

Double Life

It can often seem that our work lives are waging war on our personal lives. The Double Life layout is a list format that encourages harmony between the two. Instead of a single list of dates (as in the Life in Lists template), you'll create two lists that mirror one another, with one on each page.

 Without turning the page, you'll be able to see where your work responsibilities intersect with other commitments. Once you are aware

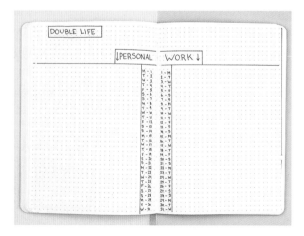

of these friction points, you can plan accordingly to head off any conflicts.

Because this layout occupies two full pages, you may need to make additional pages to track habits, task lists, goals, and other monthly items.

Advantages of the Double Life Layout:

- Can separate work and personal projects while keeping both visible
- Simple to create and read
- Accommodates more appointments and tasks than the Life in Lists layout

Disadvantages of the Double Life Layout:

- Very linear: May be difficult for people who are visual or accustomed to a traditional calendar
- Additional pages are needed for goals, habits, or monthly project notes
- Less effective for people whose schedules are not evenly balanced between work and personal projects (e.g., someone who has mostly work tasks)

Crop Top

Sometimes, a simple shift in perspective can make a huge difference in your planning. The Crop Top splits the month across two pages. This leaves the bottom half of the spread open for notes, lists, goals, or stray thoughts. Unlike other templates, your whole schedule is visible while you take notes, regardless of whether you are right-handed or left-handed.

Advantages of the Crop Top:

- Breaks the month into more manageable blocks (as opposed to one long line of dates)
- Allows for free note-taking and customization on the bottom half of the spread
- Quick and easy to create

Disadvantages of the Crop Top:

- Restricts flexibility of the list format (cannot extend each day's row to a second page)
- The month is split without regard for the day of the week (in the example, page 2 begins with Wednesday, the 17th)

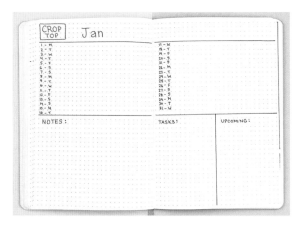

MON	TUE	WED	THU	FRI	SAT	SUN
1	2	3	4	5	6	7
8	9	10	11	12	13	14
15	16	17	18	19	20	21
22	23	24	25	26	27	28
29	30	31				

MINI GRID

GOALS

TOP PROJECTS

NEXT MONTH

NOTES

Gridlock (Calendar Grid)

Visually oriented planners are more likely to identify with a calendar grid than simple lists. Since traditional calendars line up the days of the week, the eyes can spot a Tuesday in an instant. This also allows you to count weeks more easily than a list might.

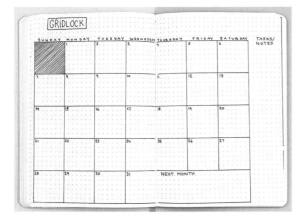

Advantages of the Calendar Grid:

- Familiar format that most people can identify with
- Can customize start date of the grid, as desired (can use Sunday, Monday or another day as the first day of the week)
- Days of the week line up for easy weekly planning

Disadvantages of the Calendar Grid:

- Very little space for notes or running task lists
- Limited space per day may require abbreviations and continued notes on other journal pages
- Takes more time to create than list layouts

Mini-Grid

While a traditional calendar grid is one of the most familiar ways to plan, it provides little flexibility in the way of notetaking. The mini-grid remedies this problem by combining the freedom of a journal with the structure of a calendar.

Turn the journal vertically, and the landscape view accommodates a small calendar. Now, the entire bottom page is free for goals, notes, monthly meal plans, projects, or whatever else you want to plan. Again, you can customize your calendar grid to your liking (this one starts on a Monday).

Advantages of the Mini-Grid:

- Maintains the traditional calendar view for visual planners
- Leaves a large area for additional notes
- You can see whether scheduled events or projects line up with goals for the month

Disadvantages of the Mini-Grid:

- Takes more time to create than list layouts
- Requires rotating the journal to use these pages
- Greatly reduces size of the calendar; be prepared to write small or abbreviate

WEEKLY PLANNING

Many people intuitively plan their lives by the week. Our work and school schedules usually follow a weekly rotation, so weekends (or whenever your rest days fall) are ideal times to prepare for the next few days.

Some people treat weekly planning pages as a bridge between monthly pages and daily task lists. For others, weeklies are the central planning elements of their journal. In some cases,

these pages are so complete that they eliminate the need for daily checklists altogether. The templates below cover a wide range of styles. Determine for yourself how much emphasis you will place on weekly planning, then choose a template to start with. Don't worry; you can always change your mind next week.

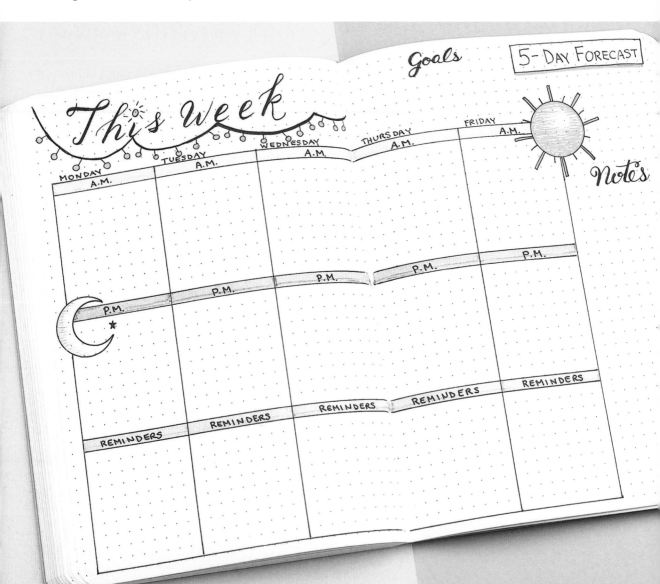

Big Easy

This layout will undoubtedly look familiar. Many printed academic and professional planners break the week into five large blocks, with smaller blocks for weekends. This format is extremely simple to set up, and it offers a large area for writing tasks and notes each day.

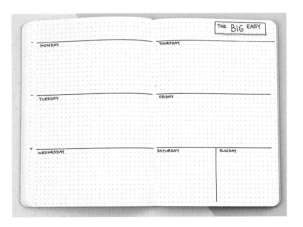

Advantages of the Big Easy:

- Familiar and easy to set up
- Offers a large space for each day's tasks
- Entire week's responsibilities visible on a single two-page spread

Disadvantages of the Big Easy:

- Does not offer notetaking space for general thoughts or undated tasks
- Recurring daily tasks, habits, and weekly goals are tracked elsewhere

Living on the Edge

Whereas the Big Easy offers the largest blocks for each day, its most notable weakness is a lack of undated notetaking space. The Living on the Edge format fixes this by squeezing the daily blocks inward. The edges of the pages now offer space for general thoughts, notes, and goals for the week.

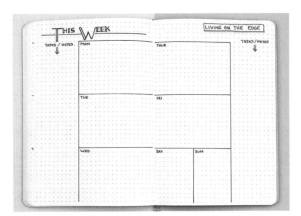

Advantages of Living on the Edge:

- Offers a large space for each day's tasks
- Entire week's responsibilities visible on a single two-page spread

Disadvantages of Living on the Edge:

- Sacrifices some daily space to accommodate notes
- Narrow columns not ideal for long notetaking

Five-Day Forecast

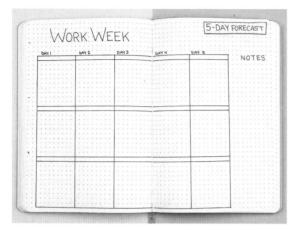

If scheduling work or school is your biggest concern, you may prefer to focus on only those days. The Five-Day Forecast format gives a wide column to each day.

To create this format, draw five equal columns to represent the days of the work week. You can also section the columns to sort tasks by time of day, type of task, location, etc. This format works especially well for students

to section their days and track assignments by course. Any remaining space on the page is used for goals, notes, or undated tasks. It doesn't have to be boring, either. This template can be bright and fun with a few decorations.

Advantages of the Five-Day Forecast:

- Full column per day allows ample space for daily task lists
- Eliminates distractions from non-work days
- Can break days into manageable blocks of time (or function) using rows

Disadvantages of the Five-Day Forecast:

- Gives no information about upcoming weekend events
- Assumes you work a standard five-day week
- Difficult for people whose work or school days are not consecutive (a break on Wednesday, for example)

The Headliner

The Headliner makes it easy to spot your appointments for the week. Since appointments have set times, the rest of the day's tasks can flow around them. People with two to three daily appointments can use this format quite successfully, and the rest of the page is completely customizable. One method is to create a column below each day for a task checklist.

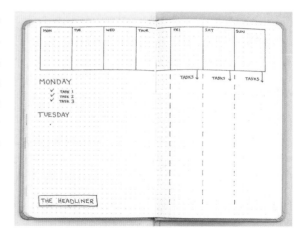

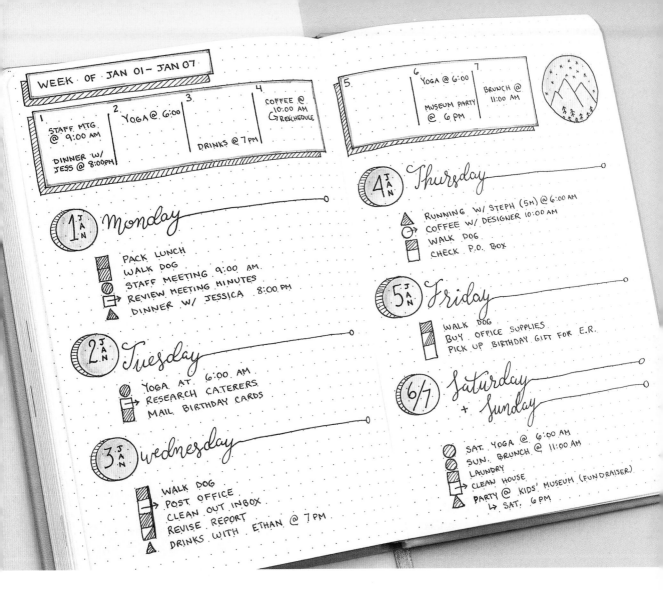

Advantages of the Headliner:

- Gives a view of full week's critical events like appointments and deadlines
- Ample space for notes or task lists
- Flexible and customizable

Disadvantages of the Headliner:

- Accommodates only two to three appointments daily
- For heavy note-takers, daily checklists may flow to subsequent pages

Like most of the templates in this book, the aesthetic changes dramatically with a little artistic embellishment. The picture above shows the Headliner as used with daily headers instead of columns to organize tasks. A few simple doodles and a touch of color make this a bright, inviting place to plan your life.

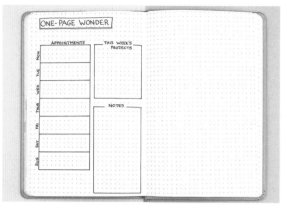
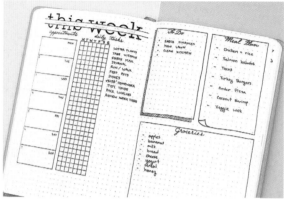

One-Page Wonder

This format is one of the least structured, but also one of the most flexible. For people who treat weekly planning as a temporary bridge between monthly planning and daily task lists, this may be the format of choice.

It is similar to the Headliner, except the weekly appointments run vertically down the left side. Because this format only occupies one page, the week can flow right into dailies on the right page. You can create daily lists freely, take notes, and let them spill over the next few pages of the journal. Alternatively, one might customize the right page with habit trackers, checklists, notes, and goals.

Advantages of the One-Page Wonder:

- Gives a view of full week's critical events like appointments and deadlines
- Requires only one page
- Flexible and customizable

Disadvantages of the One-Page Wonder:

- Accommodates only two to three appointments daily
- If dailies spill to later pages of the journal (which is likely), you must flip back to see appointment list

Even Split

The Even Split (weekly format) follows the same pattern as the Double Life (monthly format). The spine of the notebook divides mirrored spreads for work life and personal life. Each side of the page gets seven small boxes for appointments and a half page (vertically)

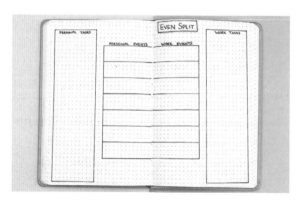

for notes and tasks. Again, this format is ideal for balancing personal and professional commitments at a glance.

Advantages of the Even Split:

- Easily compare personal and professional commitments
- Offers space for appointments and tasks or notes

Disadvantages of the Even Split:

- Very limited space is only suitable for one to two appointments per day
- No space for dailies, which would have to be placed on subsequent pages

- Less effective for people whose schedules are not evenly balanced between work and personal projects (e.g., someone with mostly work tasks)

Although it is difficult to find a weekly format that does everything you want, these should give you a good starting place. You can make small changes each week until you develop the right combination for your life. Keep in mind, you can also supplement any of the weeklies above with daily task lists, which are discussed in the next section.

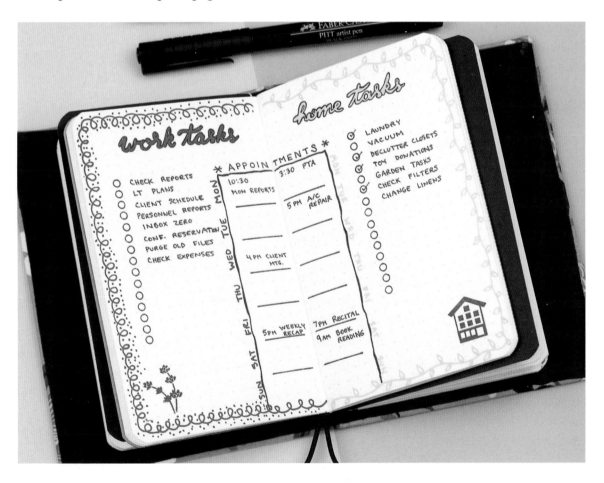

DAILY PLANNING & TO-DO LISTS

Daily checklists are one of the most focused aspects of goal-setting. These are action steps. They add up over time to become huge projects and accomplishments. Dailies can be used immediately after monthly planning pages, integrated into weekly pages (as seen in some formats in the last section), or in addition to everything else. Some people use multiple pages each day to declutter their minds, check off tasks, and plan how to allocate their time.

The combination of pages with which you add planning to your journal is completely up to you. Here are just a few ways to organize your daily routine.

Simple Daily Checklist

The simplest answer is often the right one. You have undoubtedly used a checklist of some kind before, so this should come as second nature. Label them however you like, but day of the week and date are usually safe bets. It can be helpful to have a dated record of your accomplishments, either for nostalgia or professional reference.

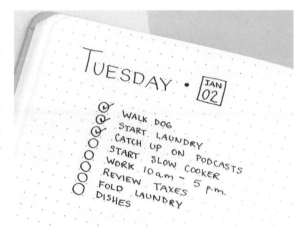

Sorted Task Lists

You can add a few elements to your task lists to make them more functional. This simple daily journal page aligns tasks differently whether they apply to work, home, or personal life. It's a handy way to prioritize tasks throughout the day.

Another great feature of this page is the appointment board just below the header. Your eyes are immediately drawn to that box, so it is an effective way to highlight the day's most important events. Notice how this page uses very few embellishments but is beautiful, clean, and highly effective.

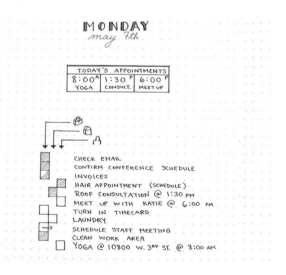

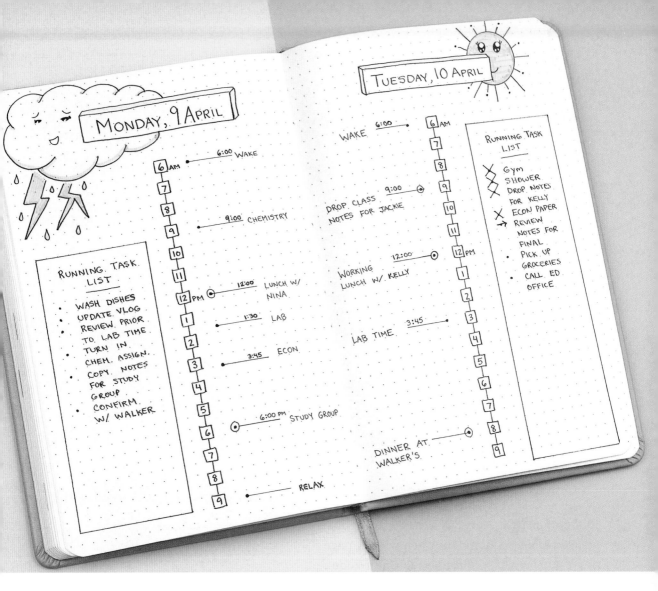

Detailed Daily Task Timeline

If you like a visual representation of your day, you might consider using a timeline view for your daily scheduling. Scheduling crunch points are easy to spot when arranged along a number line. Depending on how you set this up, you do not necessarily have to sacrifice your running task lists.

In this example, each day is given its own page. If you want some freedom for daily self-reflection or brainstorming, try allocating a full two-page spread to each day. You might use up your journal faster, but that's half the fun!

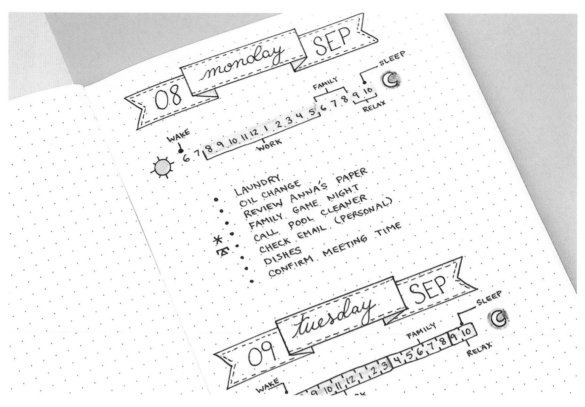

Color-Coded Timelines

Rather than treat every day as its own timeline, you can add a small timeline to any daily page or weekly layout in your journal. Color-coded timelines provide a visual of how you intend to use your time. You can assign a morning and evening focus area, or write out sophisticated timelines detailing multiple family members' schedules.

Putting these someplace visible allows you to check in once or twice throughout the day and measure progress. Create these the night prior if you cannot spend valuable minutes in the morning prepping timelines. Remember to add your timeline colors to your key so you don't forget what they represent.

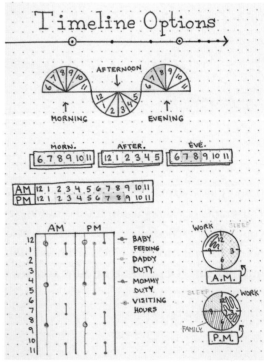

TABLES, TASK CHARTS, & HABIT TRACKERS

One of the most exciting things about journaling is seeing your life on paper. It gives form to your hopes, goals, and experiences. Contemporary journalists do not document everything for the sake of documenting; they want to make sense of it all.

The graphic representations in this section can help you unravel all the life data you collect in your journal. Armed with a deeper understanding of your behavior patterns, you can make meaningful change toward even your loftiest goals. Plus, journal users have a way of dressing up their charts to make them fun. Far from boring, these are vibrant and exciting ways to stay organized!

Habit Trackers

Habit trackers are extremely popular in the paper planning world. They give a snapshot of individual behaviors or tasks. Many people also find this process keeps them motivated to establish new healthy habits or break destructive cycles.

You can create a full-month habit tracker with a simple table of columns and rows. People who do the majority of their planning on a monthly basis may find this format especially helpful. It's a natural extension of the monthly scheduling layout.

However, others may find this many habits daunting to track. If you plan on a weekly basis, you can still use a habit chart to gain a snapshot of your week's behaviors. When establishing a new habit, it may be more useful to track *only* that item. Play around with formats, shapes, and the number of habits you track, and you may find this is the single most impactful part of your journaling practice.

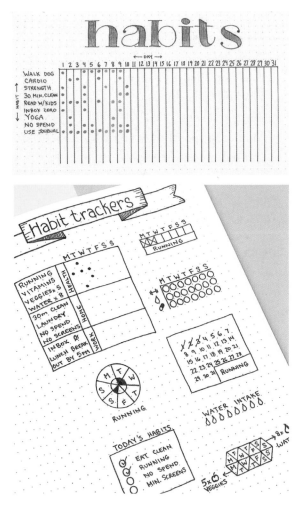

Simple Grid Table

You already saw how a grid table can work for habit tracking, but its usefulness does not stop there. Of all the tables listed here, this one will probably emerge as your most reliable and flexible format.

This cleaning schedule uses small grids to create check boxes for each item. However, you can vary the size of your columns and rows as much as you need. Make large rectangles to hold information, or keep them small to act as check boxes.

Also Useful For:

- Meal planning
- Wish lists
- Bills and spending logs
- Workout schedules
- Sleep trackers
- Medical appointment records
- Car maintenance tracker

Line Chart

Line charts are useful when you want to measure change over time. For example, if you know you want to run a certain number of miles in a month, you can create a line chart to track your cumulative distance throughout the month. Line charts also allow you to overlay different sets of measurements. In the example spread, a gray line indicates the goal, and the green line indicates the actual running distance. Flat lines represent rest days (no progress made). Overlaying the lines in this manner makes it easy to see how they relate

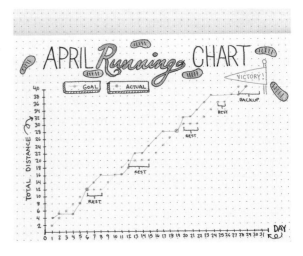

to one another. The running chart shows a cumulative upslope, but these can also be set up for downslopes or individual (noncumulative) measurements.

Charting distance is easy because it is measured in miles or kilometers. If you want to use a line chart for something more subjective, you may need to assign a measurable scale. A pain scale, for example, places a person's pain levels (subjective) on a scale from one to ten (measurable).

Also Useful For:

- Change in finances over time
- Weight tracker
- Child's change in height over a number of years
- Pain/energy/mood tracker (if assigned a measurable scale)

Bar Chart

Bar charts also measure data sets, but they make it easier to compare information. Draw your spending categories and indicate your max budget. You'll see how your budget is distributed between your expenses. In this example, the bars were open at the beginning of the month and colored throughout the month to show spending levels.

The runner who tracked running distance each month might want to see how those months compared. She could create a bar chart (twelve bars for twelve months of the year) to compare which months were her best running months.

Also Useful For:

- Satisfaction with each area of life (needs a measurable one-to-ten scale)
- Comparing months or years of finances, weight, books read, running distance, etc.

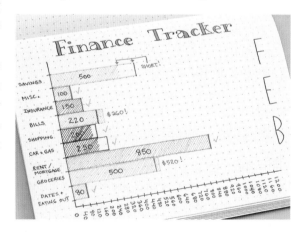

Floating Bar Chart

Floating bar charts are an incredible scheduling tool. Use them to budget time for long-term projects or keep track of many overlapping events. Each bar represents the timeframe within which a certain task or project should occur.

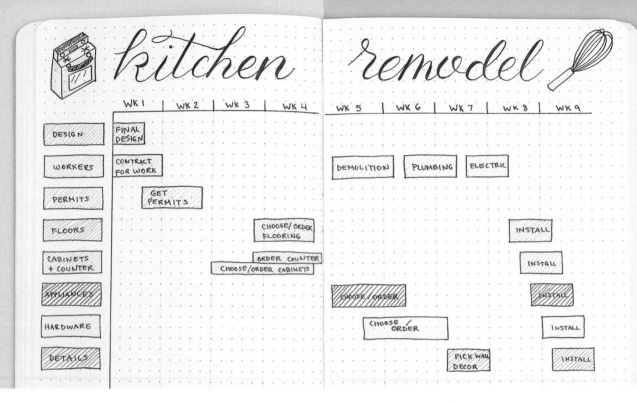

Kitchen Remodel

	WK 1	WK 2	WK 3	WK 4	WK 5	WK 6	WK 7	WK 8	WK 9
DESIGN	FINAL DESIGN								
WORKERS	CONTRACT FOR WORK				DEMOLITION	PLUMBING	ELECTRIC		
PERMITS		GET PERMITS							
FLOORS				CHOOSE/ORDER FLOORING					INSTALL
CABINETS + COUNTER			CHOOSE/ORDER CABINETS	ORDER COUNTER					INSTALL
APPLIANCES					CHOOSE / ORDER			INSTALL	
HARDWARE						CHOOSE / ORDER			INSTALL
DETAILS							PICK WALL DECOR		INSTALL

Also Useful For:

- Wedding planning
- Tracking multiple deadlines (freelance work)
- Yearly project and goal planning
- Family scheduling (kids' sports, school activities, work obligations, etc.)
- Sleep tracker (went to bed at *X* time and woke at *X* time)

Circular Charts

Many people prefer the aesthetic of circular charts. Pie charts are the most common example, and they are effective for illustrating distributions. How much of your life, for example, do you spend doing things you enjoy? A pie chart can show how much of your life—out of 100 percent—goes to different activities.

The second chart shows priorities, with the most central ones at the innermost ring. Putting priorities on paper can be an interesting

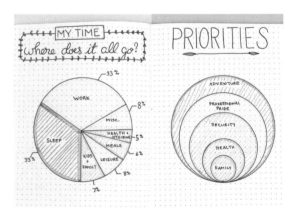

exercise, since they guide your goals and actions throughout the year.

Keep in mind, circular charts are a bit more complicated to create and may require special tools. If you are curious about other circular charts, do a quick Internet search for spider charts, radar charts, and doughnut charts (these work much like line charts and bar charts, but look a bit more creative).

Flow Charts & Mind Mapping

Journaling is invaluable for clearing your mind and organizing your thoughts. Sometimes, the noise of the world becomes so loud, you need space to sort through even the most basic aspects of your life. Flow charts can help you quiet outside influences and reinforce healthy decision-making processes.

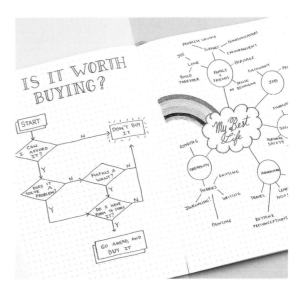

As you can see on the left side of the example, flow charts guide you to predetermined conclusions. On the other hand, mind mapping (right side of the example) sparks ideas and organizes them into a visual format. Many people find this process helps them push through creative blocks. To create a mind map, simply brainstorm ideas and record them as branches around a central topic. Each new branch triggers related ideas, breaking them down into more detailed elements. Not only does this let you generate ideas very quickly, but they're already arranged in a logical way.

FINAL THOUGHTS ON PLANNING

Life planning in a journal involves some trial and error at first. Take your time choosing which formats you'll use, and consider how your planning pages function at each level (long term, monthly, weekly, daily) and how they relate to one another. Don't be afraid to change things if they don't work. Page 1 of your journal will almost certainly look different from page 100.

As for charts, use them for special projects or when you feel the impulse to organize your life. Over time, you may choose to incorporate charts as a regular part of your journal, or you may not. Just know those tools are at your disposal. How you use your journal is limited only by your imagination.

PART II

Inspiration

One of the qualities that makes contemporary journaling so appealing is how artistic it can be. People have been using notebooks for hundreds of years to organize information, but the process was fairly utilitarian. A few easy doodles can transform journaling from drab to energizing and from work to play.

Now that you've had some time to get your planning system organized, you probably have a good idea of where you want to add artistic flair. If not, don't worry. Part 2 is all about panache! Now, creativity takes center stage. This section will also introduce decorative elements that make a big impact but require minimal artistic ability. If you find you prefer a clean-looking aesthetic to your journal, by all means, keep things simple. Sometimes minimalism is the most striking statement of all.

You can make creativity central to your page or add small embellishments as finishing touches. Drawing might be something you enjoy while you're on the phone or watching TV, or you may use it as a meditation aid. Everyone needs a break from productivity, so feel free to add fun pages to your journal, even if they are purely for pleasure. Play around with your pages in a way that makes you happy. The idea is not to put pressure on yourself to make things perfect. This is just a way of adding a little visual interest to your journal to keep you coming back to it. When the pages look this great, how can you stay away?

quotations

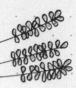

1. "Strive not to be a success, but rather to be of value." – ALBERT EINSTEIN

2. "You miss 100% of the shots you don't take." – WAYNE GRETZKY

3. "I have not failed, I've just found 10,000 ways that won't work." – THOMAS EDISON

4. "No one can make you feel inferior without your consent." – ELEANOR ROOSEVELT

5. "Success is not final, failure is not fatal: it is the courage to continue that counts." – WINSTON CHURCHILL

6. "Either you run the day, or the day runs you." – JIM ROHN

7. "A man on a thousand mile walk has to forget his goal and say to himself every morning, 'Today, I'm going to cover 25 miles and then rest up and sleep.'" – LEO TOLSTOY, *WAR AND PEACE*

8. "You're only given a little spark of madness. You mustn't lose it." – ROBIN WILLIAMS

CHAPTER 6
Special Pages & Collections

Now, it's time to dive into some creative pages! Organized layouts, charts, lists, and logs—those are just one side of journaling. The other side is where the party starts. Apart from scheduling, life hands us many opportunities and challenges that deserve pages of their very own.

Special pages and collections are among the most popular aspects of contemporary journaling. A journal is not a calendar, after all. It should reflect more of life's facets than mere scheduling. People use these pages to preserve memories, commit dreams to paper, or stockpile inspiration. Your pages can move you toward your goals, or they can simply be for fun. Either way, you'll love flipping through your old journal pages in the future.

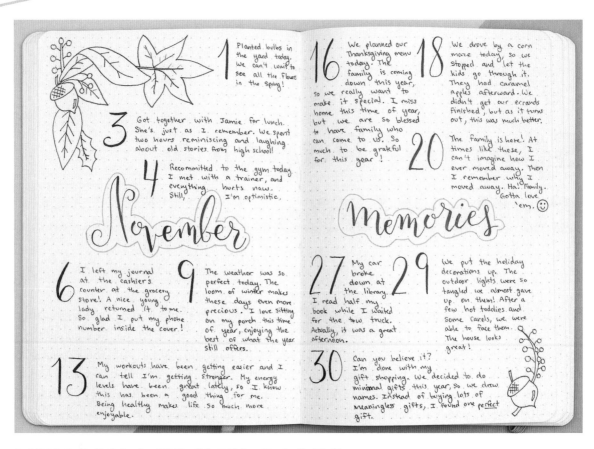

MEMORY & TRAVEL PAGES

Memory-keeping has long been a part of journaling. Maintaining a collection of monthly memories is a simple way to document important milestones and treasured moments. Unlike with traditional journaling, creative memory pages are more likely to use a variety of media, colors, creative lettering, doodles, and sketches to showcase life experiences. Create a format with which you identify: structured lists (one line per day), a full page of colorful illustrations, sporadic dates and memories—any format that speaks to you.

If you prefer a less linear approach, Memory Wheels are a lovely way to arrange recollections. They work well as monthly memory trackers, or even as end-of-year memory summaries. Simply gather your top memories from each month and display them on the annual Memory Wheel.

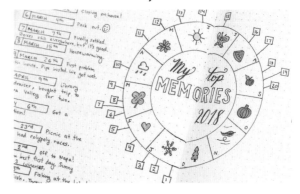

What better time to document memories than while exploring a new place? Travel spreads are so popular that people dedicate entire journals to their creation. One of the simplest travel spreads to create is a travel wish list (or bucket list). Seeing those exotic places on paper might even motivate you to save and plan toward that trip you've been putting off.

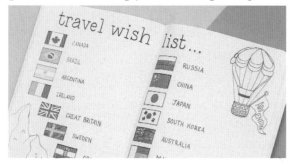

When you finally do make it to your destination, you'll be able to check it off your list. Maps are a great way to celebrate not only the geography of travel, but also the romance of heading into the unknown. Try tracing a map outline (world map, region, or country) into your journal with graphite paper, and color places as you check them off your list.

Journals are meant to be mobile. They travel with you, which makes it possible to document feelings and observations as they occur. All the details—smells, sounds, funny mix-ups, interesting historical facts—can be lost over time. Attempting to capture those subtleties can go well beyond the abilities of your pen. Try adding photos, tickets, receipts, or ephemera you

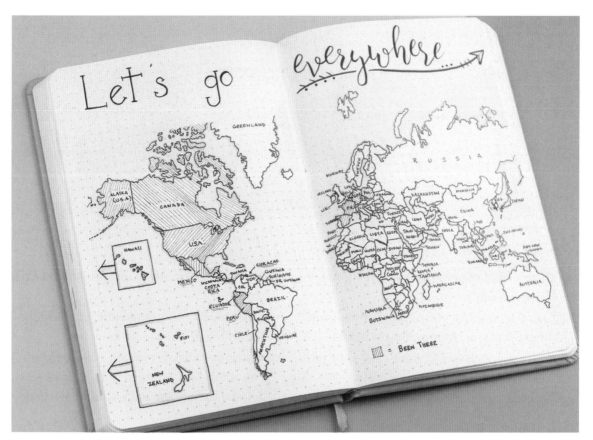

collect on your trip. They make great souvenirs, pack well, and won't cause you any grief in customs. The travel photos here were printed on sticker paper with a pocket-sized mobile printer. More artistically inclined people may prefer to sketch or paint their experiences. Either way, journaling allows you to seamlessly blend the delights of both scrapbooking and writing.

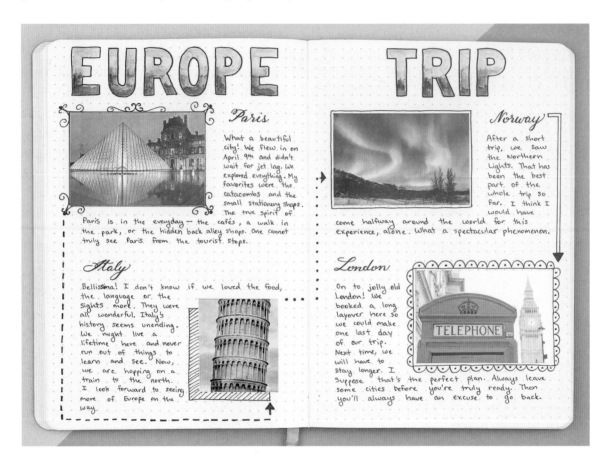

More Ideas for Memory & Travel Pages:

- Draw a road trip route with attractions along the way.
- Create a page to collect a single item from different places (stamps, flower petals, etc.).
- Chart your child's height each year.
- Create a birthday time capsule.
- Track news headlines on special days each year.
- Examine memory fragments in your journal. What do they mean to you?
- Use your journal to revisit a place from your past. Make note of important objects, smells, and people who would have been there.

HEALTH & WELLNESS

Mahatma Gandhi said, "It is health that is real wealth and not pieces of gold and silver." Balancing modern work schedules with the fundamental need for exercise, good nutrition, and mental well-being can be a challenge. Special journal pages that support a healthy lifestyle are a great way to maintain focus and reinforce wholesome habits. Tailor the layouts to specific goals, such as weight loss, gaining strength, lowering cholesterol levels, or taking a more holistic approach.

A healthy eating guide can reinforce good decisions at the grocery store, where countless temptations are likely to derail our efforts. This could also serve as a master grocery list of sorts. People following a specialized diet plan can create pages to remind them of foods to choose or avoid. Your journal will ensure these important pages are always within reach.

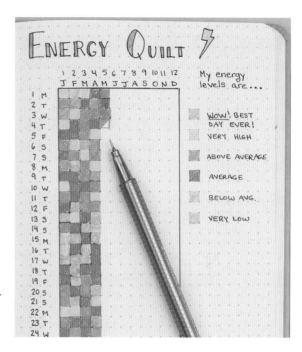

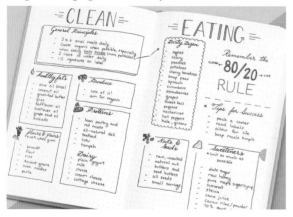

Sometimes, healthier living starts with awareness of how current lifestyle choices affect overall well-being. Energy levels, for example, fluctuate throughout the day (or month) for a variety of reasons. Tracking your symptoms can reveal a pattern, and over time you may discover a particular habit was contributing to low energy levels. Even though the spread above was not intended to address any serious health concerns, it nonetheless reveals valuable information. This same format adapts easily for tracking mental health factors like mood or outlook. People with more complicated medical questions might develop pages with their healthcare providers to observe symptoms over time.

Custom exercise trackers can demystify how your physical activities affect overall health. The market is flooded with different fitness journals, but they approach fitness from one perspective: their own. Everyone has different limitations and objectives. A runner might perceive fitness based solely on time or endurance. A fitness model, on the other hand,

has to consider body fat percentage and overall muscle tone. An outdoor enthusiast might prefer to track the number of mountains she climbs in a year, taking notes on the terrain and length of each hike. A yogi has an entirely different set of objectives, including strength, flexibility, and mental clarity. All of these are fitness activities, but they call for distinctive exercise trackers. Your pages will mold around your lifestyle.

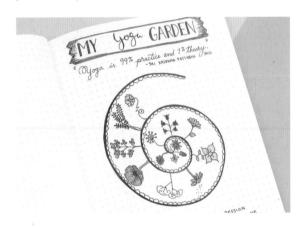

More Ideas for Health & Wellness Pages:

- Track weight, strength, or measurements (losses or gains).
- Establish mood patterns based on daily, monthly, or yearly cycles.
- List activities that make you happy.
- Incorporate self-care into a journal routine.
- Use lists to reinforce positive body image (e.g., "I love my body because_____").
- Track sleep (number of hours and quality).
- Create a food and vitamin log to track dietary habits.
- Track immunization or medical check-ups.
- Design specialty pages specific to individual medical needs (blood sugar trackers, pain levels, pregnancy, etc.).
- Design a meditation log (date, time, duration, and results).

LISTS TO LIVE BY

Journaling tends to attract natural planners: people who love to think ahead, organize information, and make lists. Lots and lots of lists! They are not all task lists, either.

Many people collect encouraging quotations on a continuous list. Try it out. When you hear words that inspire you, add them to your list. On tough days, you can turn to these quotations for a much-needed boost in confidence. Others enjoy weaving motivational quotes in with their regular journaling pages: a quote of the month on a planning spread or a hand-lettered proverb to fill an awkward blank page.

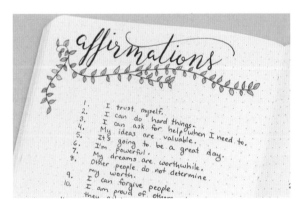

Infusing pages with positivity can change how people perceive their situations. Likewise, affirmations can also help guide positive thinking about a situation, our loved ones, or ourselves. When confronted with a negative

situation, conjuring a positive thought can prove challenging. An affirmation list provides those positive phrases when they are needed.

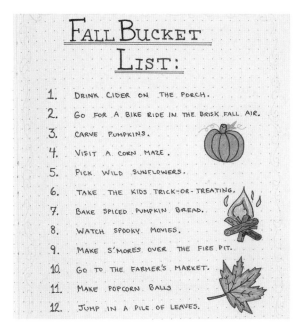

Bucket lists are a fantastic way to energize any routine. These simple wish lists can cover a lifetime, a month, a season, or a certain point in life (e.g., "By the time I'm 35, I want to..."). They remind you to fill your life with rich, meaningful experiences (not necessarily base jumping) rather than allowing yourself to float from one task to another. Try letting your family create a summer bucket list together so that each person has a say in vacation plans. Create a list of seasonal activities you enjoy. The challenge for list-makers is to keep their bucket lists from becoming yet another to-do list. Bucket list items aren't chores. Enjoy the experiences without worrying about actually completing the list.

Some lists have more practical purposes, such as a list of favorite meals. Keeping various meal idea on hand can be particularly helpful for busy parents, who dread the question, "What's for dinner?" After a hard day at work, few of us still have enough creative energy to improvise a gourmet meal. A running list of family favorites can help simplify meal planning, grocery shopping, and last-minute cooking. Try segmenting meal lists by kid-friendly favorites, healthy alternatives, or meals that use certain ingredients. Also consider separating favorite meals by season. This will help you take advantage of in-season produce, which generally costs less and adds variety to your meal routine.

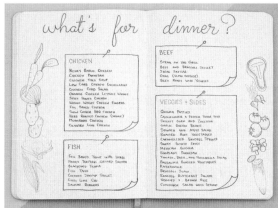

More Ideas for Lifestyle Lists:

- Gratitude list
- Things to work on
- Skills to learn
- Questions to research
- Favorites
- Gift lists
- Family activities
- Important addresses and phone numbers
- Home repairs and vehicle maintenance records
- Methods for relaxation

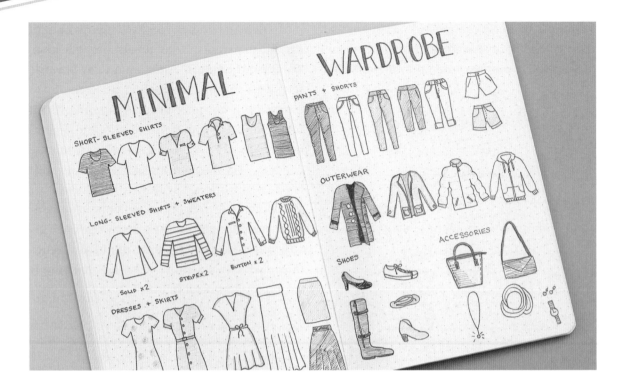

SPECIAL PROJECTS

Life is full of projects, large and small. Sometimes, the most difficult part of any project is creating a plan and staying organized throughout. Journaling can bring clarity to even the most complicated situation. Sometimes a simple list will do, but other situations call for a more visual approach.

Home organization is a source of significant stress for many people. Our needs change throughout our lives, so we purchase items to meet those needs. Over time, our needs change, but the items accumulate, so we have to find a way to organize, repurpose, or get rid of things.

Let's look at wardrobes as an example. Most of us have items in our closets we can't (or won't) wear ever again. Perhaps we're even missing key pieces that would make our existing clothes more wearable. How do we maintain an affordable, flexible, and timeless wardrobe without all the stress? Creating a visual representation of your wardrobe (or ideal wardrobe) can help organize those items and identify areas that need attention. Plus, since your well-planned wardrobe is in your journal, you'll be able to reference it when shopping for new pieces. Treating your clothes with an intentional philosophy can help you start each day with confidence and ease.

Of course, having a plan can bring peace to any area of life, whether managing a large corporate project or decluttering a craft room. People often forget to use their journals to plot out home projects. Landscaping is labor

intensive, so it makes sense to have a plan before any digging begins. This gardening page shows the ideal locations of structural plants and flowers based on the sunlight levels of each area of the yard. Investing thirty minutes in this journal page will ensure each plant has the ideal environment and save hours of frustration in replanting.

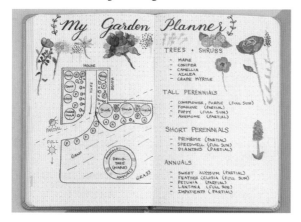

In the quest for self-improvement, many people participate in special challenges. By creating dedicated pages for these undertakings, you solidify your commitment to completing them and add a little bit of motivation. The challenge page arranges the works of William Shakespeare like a game board. As the person moves from one color-coded section to

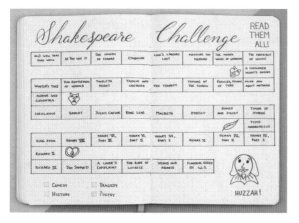

another, the reader takes on new types of literature. The goal of the spread is to read Shakespeare's works. As far as anyone can tell from this photo, there is no larger motivation for this challenge other than personal ambition and enjoyment. Some people prefer coloring or doodling an object when they complete a specific challenge item. Reading challenges, for instance, could involve filling in a doodle of a book for each one read. The same technique works for movie marathons, television series episodes, savings, losing weight, completing college credits, and so on.

Some projects become so involved, they deserve dedicated journals. Writers or actors, for instance, might keep journals packed with notes on the study of their crafts. Travelers, especially, seem to enjoy having travel notes in separate journals. Some even go so far as to segment their journals by location. Reading journals are also popular in the journaling community. Many of these are fairly simple lists of books to read (or books that are being read), while other book lovers write out pages of notes on each book: story summary, author style, notable quotes, and reactions.

More Ideas for Special Project Pages:

- Moving checklist
- Job application process: tracking inquiries and interviews
- Room-by-room decluttering plan
- Home remodeling projects
- Homeschooling curriculum
- Major professional endeavors: writing a book, starting a blog, creating a course, pursuing research funding, starting a company, etc.

BOLD

Cc D

H

M

R

W

goals

upcoming

SERIFS

Hello,
Fall!

FINISH
ENDS

CHAPTER 7
Header Styles

At its core, journaling is an exercise in self-expression. You breathe life into the pages with each pen stroke, transforming a blank notebook into a written manifestation of your unique life. Contemporary journaling goes far beyond words, though. The artistic elements favored by many modern journal enthusiasts are a huge part of its allure. This is your happy place. Embellish it in a way that makes you want to hang out for a while.

Headers (or titles) are one way to add personality to a page. They can also show what type of information the page holds. When you turn to a specific spread in your journal, the colors and shapes on the page are reminders for what's on the page (even before you've had a chance to actually read the title). Many people notice their moods change when their pages look a certain way, just as your spirits might lift by going outside or to your favorite reading chair. Showcasing your lists with fine headers may also help you perceive them as more important.

That being said, fancy lettering is certainly *not* required. Simplicity is sometimes the most appealing style of all. Be true to your tastes and aesthetic preferences. Let your journal's style emerge naturally, without concerns about whether it conforms to any particular trend.

There's also a time and a place for being creative. Occasionally, someone can get so focused on having perfect journal pages they become paralyzed, unable to draw a single stroke. Try to remember that this is a journal, not a museum. If you're in a hurry and need to make a simple to-do list, let productivity lead in that moment. Make the list. That is not the time to get bogged down over whether an "A" is straight enough. Later, when you're relaxing, you can let your journal shift back into creative mode—unpack all the colored pens and stencils and go wild.

In this chapter, you'll learn four easy lettering styles you can use to create hundreds of headers. They are demonstrated on grid paper to better show to how the letters align relative to one another. I am not, by any stretch of the imagination, a lettering artist. If I can create these styles, anyone can. It just takes a little practice. The examples here are not perfect. Yours don't need to be perfect, either. Embrace the mistakes, practice, experiment, and have fun! After all, the only person who needs to love your journal is *you.*

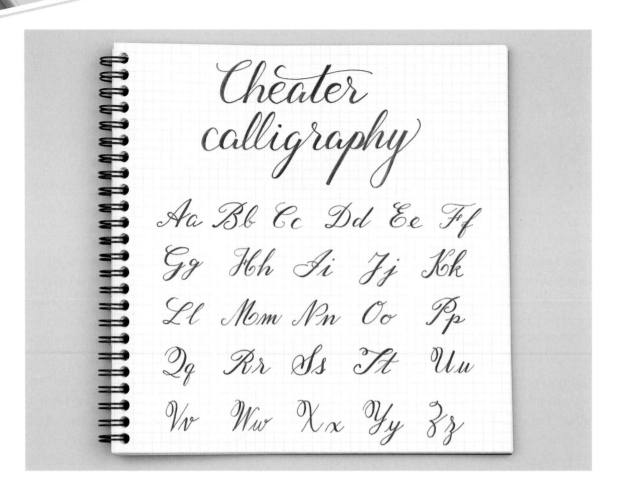

CHEATER CALLIGRAPHY

Who can resist the graceful curves and flourishes of fine calligraphy? It's beautiful, elegant—and difficult to master. Luckily, there is an easy alternative. Cheater calligraphy is a simple way to add fancy, scrawling letters to your journal, but you don't need special ink or pens. Plus, the techniques are easy enough for beginners. Many people like this lettering style because it is forgiving. Cursive letters have many dips and curves, so imperfections either go unnoticed or look like deliberate stylizations.

You'll need your favorite fine-tipped pen. An ultra-fine felt pen works well, but use whatever you are comfortable with. If you like, you can trace your design lightly in pencil first. In my personal journaling, I jump straight to ink whenever possible. Sketching everything in pencil only feeds the perfection monster, and each page takes twice as long. Mistakes are no big deal. Still, when trying new lettering styles, pencil can alleviate frustration.

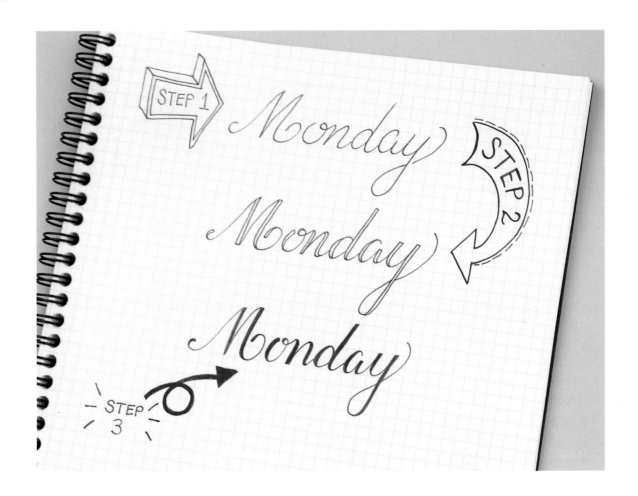

Step 1: Write the Word in Cursive

Using the page lines as a guide, write the title or header in cursive. Square grid and dot grid notebooks are especially useful in these circumstances because they guide the eyes both vertically and horizontally. Don't worry if things are a little uneven or rough. These are handwritten words, not computer printouts.

Step 2: Add Lines on Downstrokes

Draw a second set of lines in your word, one for each downstroke. The downstrokes are any part of a letter where your pen moves downward to form the line. Curves, for example, the legs of an "A," or the tail of a "g."

Your lines should run roughly parallel to the original downstrokes you made when writing the word. You may cross over other parts of the letter. That's fine. Once the letters are filled, it won't be noticeable.

Step 3: Color or Fill in the Downstrokes

Finally, fill in the downstrokes. The thick downstrokes create the illusion that the word was written with a brush or calligraphy pen.

Variations and Header Examples

Instead of blackening your downstrokes, you can leave them open or fill them with color. To do this, leave small gaps for the downstrokes when you first write the word (Step 1). This will ensure you don't have any lines crossing through the downstrokes. Notice the small gap between the "a" and the "l" in the photo. It prevents the stem of the "l" from having a crossing line in it. It is only necessary to leave the gaps if you do not intend to blacken the downstrokes.

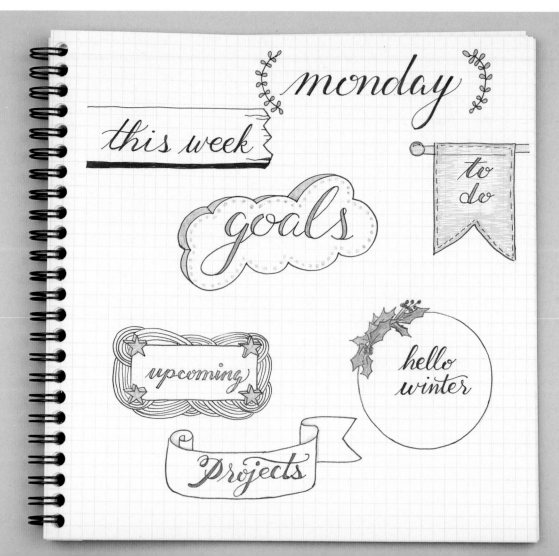

Cheater calligraphy works well as a header on its own or with other artistic elements. Plain black is boldly elegant, whereas the colored versions create a more casual effect. Adjust the size, or add frames, doodles, and colors until you achieve the desired effect. Once mastered, this technique is a quick and easy way to add stylized headers to any spread.

SIMPLE & BOLD

Clean and simple approaches to journaling should not be overlooked. A well-organized page with modest lines makes important information more prominent. Many people find minimal journal pages calming. When life looks simple on paper, it can be easier to tackle the day's events. For these people, a simple header is in order.

This lettering style is fairly straightforward. This is a sans-serif font (meaning it lacks the little feet used on more formal fonts). To keep the aesthetic as simple as possible, it uses only capital characters. Use all one size, or make lowercase characters half the size of the capitals.

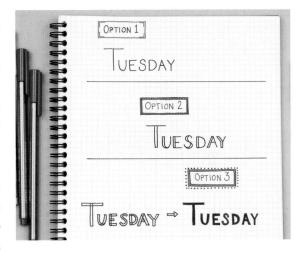

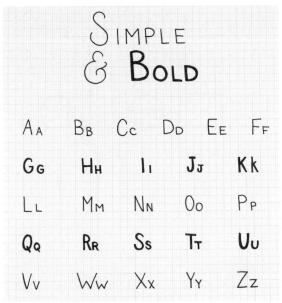

As with cheater calligraphy, you can create simple header variations. If you want to keep things ultra-simple, leave off any banners, underlines, or doodles and limit colors to only small accents. Option I is the simplest. It looks clean, casual, and unassuming. Since this lettering doesn't have any required flourishes, it is one of the fastest to make. Add a title to your page in a flash and get back down to business.

The second variation uses the same technique as cheater calligraphy. Just add a second set of downward strokes to the letters, and fill in as desired. This complicates the aesthetic a bit, but not so much that it will overwhelm a simple page.

To create the third variation, thicken the entire word. It makes a bigger statement and takes a little longer to create than the other

variations. Alternatively, choose a thicker pen tip to create a bold effect without the extra steps.

Even if you like a more artistic header, you may appreciate the versatility simple lettering can offer. On its own, this is the ideal minimalist header, but it also works extremely well when enhanced with doodles and color accents. Even the more artistic header styles pictured on the right are balanced out by the simple lettering. I suggest starting with the simplest form and adding to it until you find the right look for you.

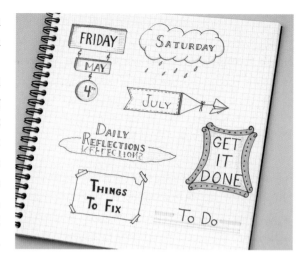

TYPEWRITER FONT

Aa	Bb	Cc	Dd	Ee	Ff
Gg	Hh	Ii	Jj		Kk
Ll	Mm	Nn	Oo		Pp
Qq	Rr	Ss	Tt		Uu
Vv	Ww	Xx	Yy		Zz

Typewriters and their distinctive fonts remind us of pre-digital days. For those of us who embrace journals—the ultimate analog devices—adding touches of nostalgia to our pages is a natural fit.

The most notable characteristics of this lettering style are the prominent serifs (the little feet at the top and bottom of many letters) and overall uniformity. The short lowercase letters are half the height of uppercase letters, the curves mimic circles, and the straight lines are *really* straight. Of course, this is handwritten typeface; we won't attempt to reproduce what a typewriter can do. Make your letters as uniform as possible, then accept the wiggles and crooked letters as part of the fun.

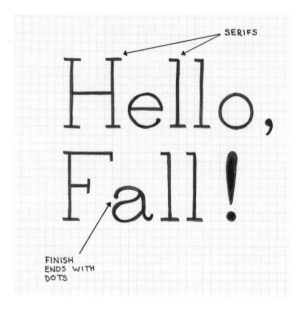

This style can be tricky at first. The letters are relatively simple, but their mechanical appearance presents its own challenges. Unlike cursive, this style makes it difficult to hide errors. Until you become comfortable with this variation, practice a few times in pencil. After a while, you will instinctively recognize the correct width and height for each letter.

Spend some time studying the letters that differ greatly from the way you write them by hand. Lowercase "g" is especially troublesome with its tiny curves, ears, and ovals. Take a look at the alphabet provided or study other examples of typewriter font. Once you make out the specific pattern of each letter, you can reproduce them with ease.

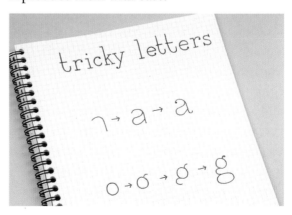

This style is so distinctive it barely needs any other embellishment to make a big statement (apart from my obligatory typewriter doodle). These headers rely on the font's natural aesthetic. Try it on its own, then spice it up with the occasional doodle or pop of color. It is sure to become one of your favorite ways to dress up your journal pages.

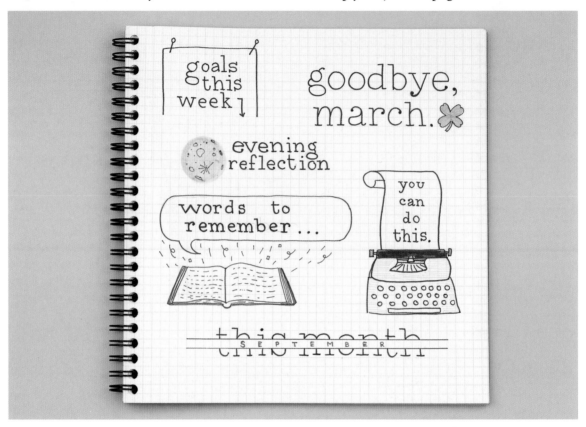

QUIRKY & FUN

Whereas the typewriter font is controlled and uniform, this last lettering style is all about variety! There's no holding back with this style. If anything, the hardest part is deciding which color to use next. Admittedly, switching colors and adding embellishments to every letter can get complicated. It may not be the header to use when you're in a hurry, but it is great to let loose occasionally on a few creative pages.

The key with this style is to mix things up. Stack curvy letters with boxy ones, add patterns, add curls, and even turn your letters into butterflies and trees. In the sample alphabet, I've colored some letters and left others in plain black. You could also experiment with an all-black version or switch colors on every letter. Flip some of your characters backward, if you like. There are no rules at all with these letters.

Likewise, the headers you create with this style can spice up any page. Only basic banners or boxes frame most of these, but they practically jump off the page. Since the letters already pack a punch, they act as their own embellishments. Play around with different color combinations, squiggles, dots, boxes, doodles, and shadows.

If you struggle with any of these lettering styles, print some of your favorite fonts and trace them for practice. You can even transfer them to your journal with graphite paper. Over time, your hands will become accustomed to the shape of the letters. Don't waste too much energy on trying to make things perfect. No one is grading you. Regardless of which header styles you choose, always consider your personal style and objectives. If you don't have time for fancy or creative, keep things simple. If you get bored of your regular header, add some color or a few embellishments. This is your journal. Make it your favorite place to spend time!

PING

LIST

- ☐ FOLDING CHAIRS
- ☐ GAMES + GUITAR
- ☐ DISH TOWELS
- ☐ SUNGLASSES
- ☐ S'MORES

⭐ ⭐ ⭐ ⭐ ⭐

IGHTTIME GEAR

TENT

SLEEPING BAGS

ILLOW

NTERN / FLASHLIGHT

R CHART

TCH

MONTH

date

TIT

titl

TIT

CHAPTER 8

Banners, Frames, & Borders

Artwork has become a central part of contemporary journaling. Not only is it visually stimulating, but it can also organize information. Banners and signs create striking page titles. Frames and borders break large pages into smaller, more usable sections. Of course, a simple line is a perfectly acceptable page divider. However, doodles and artwork can enrich your relationship with journaling.

Take page titles, for example. Their function is to communicate what's on the page. Framing titles with a doodled sign or banner is purely aesthetic, but it can make a page appear polished. You may find that devoting time to embellishing your journal pages reinforces your commitment to the information within: "This page is important to me. I'm going to make it beautiful and *truly* devote effort to incorporating it into my life."

Whether you favor simple artistic touches or explosively colorful pages, this chapter will cover some easy techniques to get started. If you're a complete beginner, follow the steps and practice until you feel comfortable. If you are already comfortable with visual art, add your own touches to these ideas, or reinvent them altogether. In the end, you'll have beautiful pages that also create order, preserve memories, and inspire you to grow as an individual.

MAKING BASIC BANNERS

Banners and signs add impact to page titles. They are simple to draw and can still present information with a flourish. Banner shapes also adapt to the space they fill. For example, page or section titles call for a ribbon-like banner that spans the width of the page (or section). A date, on the other hand, works better on a small banner off to the side.

This section teaches you how to make basic banners and signs. I could never cover all of the possible options, but these examples will give you some basic skills to build on. Most use simple lines, so even if you don't have natural artistic talent, you'll be able to reproduce them. Experiment with different angles, decorations, and colors. With a little imagination, you'll be able to create hundreds of variations to keep your journaling fresh and exciting.

Simple Banner

The simple banner is versatile and extremely easy to draw. It pairs well with hand lettering, calligraphy, visual note-taking, and journaling.

- Step 1: Draw a rectangle. The size will depend on the words it will hold. You may want to write your title first, then draw the rectangle around the title. You can use a straight edge if you like, but casual, hand-drawn lines also have a nice effect.

- Step 2: Add horizontal lines to each side (left and right) of the banner, offset from the top edge. Draw another set of lines below that, extending from beneath the rectangle. Do not connect the lower lines.

- Step 3: Draw vertical lines to connect the bottom edges of the banner. Finish the left and right edges of the banner with a sideways "V."

- Step 4: Draw two short diagonal lines to connect the bottom corners of the rectangle with the lower lines of the banner. Color and decorate as desired.

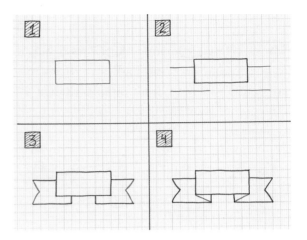

Market Sign

Unassuming and casual, market signs usually pop up at temporary events. They remind us to seize experiences before the chance is gone. You can bring a little festival charm to your journal by dressing up your page titles with a market sign.

- Step 1: Draw two curved lines (to match the length of your title). Try writing the title first and adding the lines to fit the space.

- Step 2: Connect the sides.

- Step 3: Nest one small circle inside another to make a grommet. Repeat in each corner.

- Step 4: Draw lines (ropes) from each grommet to the edge of the paper. Color and decorate as desired.

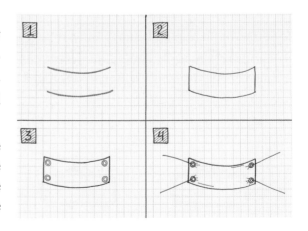

Tip: When drawing with ink, objects in the foreground should be drawn first. To make flowers spill over the edge of the sign (as in the example), draw the flowers first, then create the rest of the sign around them.

Simple Scroll

Scrolls create a romantic effect that brings to mind a bygone era. They look fancy, but scrolls are actually easy to draw. Simply change the direction of your swirls to make different rolling effects.

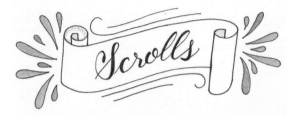

- **Step 1:** Draw a small spiral. Extend the spiral into a sweeping line and finish the end with another spiral.

- **Step 2:** Beginning at the outside edges of the spirals, draw three vertical lines downward. Longer lines will create a tall, thick scroll. Short lines will make a ribbon-like scroll.

- **Step 3:** Close the bottom edges of the scroll. These lines should follow the same curves as the upper edge of the scroll.

- **Step 4:** Draw short vertical lines to connect the inner edges of the spirals. The number of lines needed depends on how many rotations are in the spirals. Color and decorate as desired.

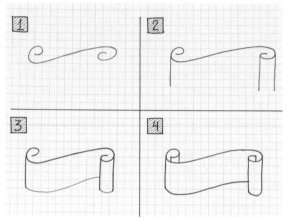

Marquee Sign

If you want pizzazz and energy in your pages, a marquee sign is the way to go. Decorating your page title with one of these makes it seem like the hottest show in town. Try this simple version, or take inspiration from real-life signs and incorporate them into your journal.

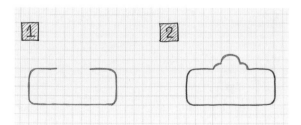

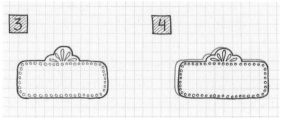

- Step 1: Draw a rough rectangle with rounded edges. Leave a gap, centered at the top of the rectangle.
- Step 2: Add three small curves to make the crown of the sign.
- Step 3: Decorate the edges with small circles to represent lights. Add small embellishments to the crown as desired.
- Step 4: Add a shadow line to create a three-dimensional effect. Color and decorate as desired.

Fancy Banner

Some pages call for a dash of pageantry. This banner is not difficult to make, but any page it adorns will seem particularly special. This banner style also makes elegant flags when only one side of the folds are drawn.

- Step 1: Draw a long sweeping line (the desired length of your banner's title area), and finish it with alternating squiggles.
- Step 2: Finish the sides and bottom edge of the main banner area.
- Step 3: Draw a second set of squiggles from the opposite corner of the first.
- Step 4: Finish the edges of each fold in the banner. Taper the height of the banner with each fold in order to create elegant pointed ends. Color and decorate as desired.

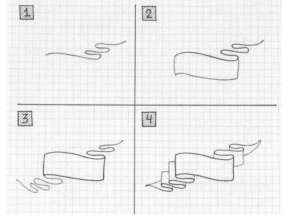

Clothesline

Banners and signs are not confined to simple rectangle shapes. You can make each letter part of a whimsical illustration. This clothesline is a fun, imaginative way to label a page, but it works best for short titles.

- Step 1: Draw a dot to represent the hinge of the clothespin. Add one half of the clothespin with the teeth pointing inward.

- Step 2: Add the letter to the clothespin. Not all letter shapes can clip in the center (such as "H" and "N"). Choose a high point on the letter to connect with the clothespin.

- Step 3: Draw the back half of the clothespin.

- Step 4: Add the rest of the letters, making sure that all clothespins are at the same height. When all letters are complete, draw a line though the center point of all the clothespins. Color and decorate as desired.

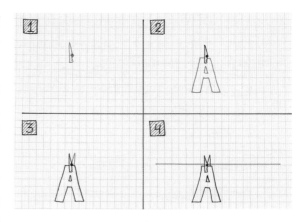

Tip: If you struggle to envision where each letter will be clipped, write the letters lightly with pencil before drawing the clothespins.

FRAMES

When you need to isolate something in your journal (such as a list, quote, or reminder), a simple box can do the trick. Frames accomplish the same function, but with a little more visual flair. Plus, they are a breeze to draw.

Shadowed Notes

Shadowed notes are among the simplest and most useful embellishments for creative journaling. You can use shadows to add dimension to any area of your journal. They highlight important elements and add a little pop of imagination.

- Step 1: Draw a square or rectangle to cover the desired space.

- Step 2: Add offset lines that mimic the angles of the note to create a basic shadow.

- Step 3: Experiment with different line angles to create various shadow effects.

Stacked Notes

Purposely creating messy doodles can relieve the need to make everything perfect. How many of us haven't had a stack of sticky notes on our desk at some point? Creativity sometimes needs a little untidiness.

- Step 1: Start with a box the size and shape you desire.

- Step 2: Add another note (similar shape and size) behind the first box. Make sure it is slightly askew.

- Step 3: Repeat Step 2 until you have the desired effect. Add colors or shadows as desired.

Notebook

It might seem redundant to draw a notebook in a notebook, but that's part of the fun. Small depictions of everyday objects add depth and interest to any page.

- Step 1: Start with a rectangle around the information you want to frame.

- Step 2: Add offset lines to represent the other pages of the notebook.

- Step 3: Draw a line of circles to represent the holes along the spine. Add curved lines inside the holes to give them dimension.

- Step 4: To make the spiral binding, draw a curved line from each hole to the spine of the notebook. Add color and decorate as desired.

Easy Frames

We frame pictures and paintings to emphasize their value. Give your important lists, notes, and favorite quotations the treatment they deserve with this quick doodle frame.

- Step 1: Draw a rectangle around the area you want to frame.

- Step 2: Add a small curved line at each inner corner of the rectangle.

- Step 3: Connect the curved corners with straight lines. Add color and decorations as desired.

Circular Frames

It's easy to forget about circles and other shapes, especially when writing on a rectangular page. Circular frames are a stunning way to enhance small elements or entire sections of a journal. This adaptable technique also works well for floral wreaths or circular patterns.

- Step 1: Lightly sketch a circle in pencil. You can also use a compass or helix stencil as a guide.

- Step 2: Add decorative elements along the circle. Experiment with leaves, flowers, stars, everyday objects, and patterns. Different elements will dramatically change the final effect.

- Step 3: If there are any blank portions along the circle (where you did not add doodles), connect them with a simple line. This will

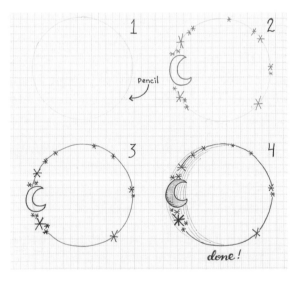

ensure your frame is defined and doesn't blend into other elements on the page.

- Step 4: Erase stray pencil marks, add color, and decorate as desired.

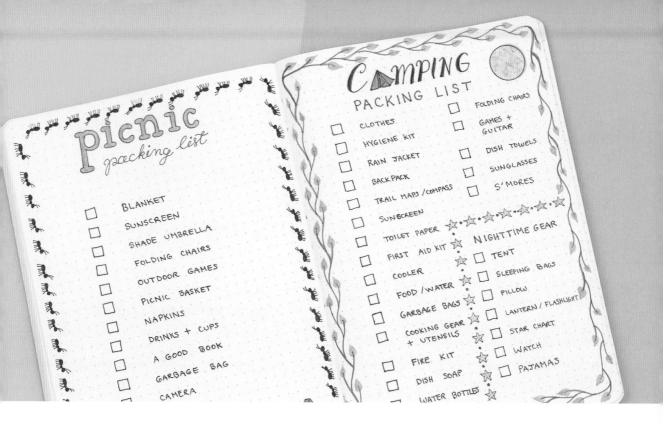

BORDERS & DIVIDERS

Sectioning a page into smaller areas allows you to maximize your use of space. Not only do these little doodles create a fun ambience, but they are also a colorful and exciting way to enhance structure. Use them to separate notes or indicate a new day. Line the outer edges of a page, or break it into smaller sections. Go wild if you want!

Simple Borders

Any string of small doodles can act as a border. Play around and combine them in new ways. Minimal elements add style without a lot of fuss. Even circles and straight lines can create amazing visual impact. The key is to repeat simple elements until they form a long enough line. Choosing plain black ink will create a classic minimalist aesthetic, or you can choose whimsical elements and colorful patterns that match your topic, such as animals, objects, or

icons. Try combining and swapping icons to form different patterns.

Floral Borders

Floral borders are quite popular, and they're a bit more involved to create. The good news is they aren't complicated at all. Just like other borders, they string simple doodles together in a pretty arrangement. Remember to draw your foreground first. Otherwise you'll have lines cutting through your flowers. Here's an easy example to get you started.

- **Step 1:** Draw a line of basic flowers, spaced out across your desired border area.

- **Step 2:** Connect each pair of flowers with a looping vine.

- **Step 3:** Add small leaves along the vine. Color and decorate as desired.

Ribbons and Strings

Ribbons and strings are a fun way to give your journal a crafty look with texture and dimension. Although they look complicated, this technique will help you make a perfect rope border every time.

- **Step 1:** Start by drawing a shallow "S" curve. Repeat the shape until you reach the desired length.

- **Step 2:** Close the final "S" by connecting it back on itself.

- Step 3: Draw half a tassel from the end of the rope. Add the second half of the tassel. This suggests the rope unraveling.

- Alternate Step 3: You can also finish the ends with a clean look. Simply square off the ends after closing the final "S."

- Step 4: Draw small lines inside each rope section to add texture. Color and decorate as desired.

Whimsical

Here's where you can really unleash your imagination. Create a border from any small doodle you can dream up. You can have so much fun tying borders in with the pages they adorn. Add strings of animals, mythical creatures, faux washi tape, shooting stars, or funny character illustrations. These marching ants make adorable page borders in the summer, and they're drawn with nothing more than dots and dashes.

- Step 1: Draw a medium-sized dot to represent the ant's head. Add a small dot for the thorax midsection and a larger oval for the ant's abdomen.

- Step 2: Add short lines to represent six legs and two antennae.

- Step 3: Repeat the steps above until your line of ants is long enough.

- Step 4: To finish the line, add a food item, picnic basket, ant hill, or other amusing doodle. Decorate and color your doodles as desired.

There's no end to the number of borders you can make with a little imagination. Work through the step-by-step examples above, then practice some of the other patterns in the photos. Practicing will inspire you to come up with even more border styles of your own.

CHAPTER 9
Doodle Embellishments

Sketches have long been a part of journaling. Before photography was prevalent, explorers and scientists drew landscapes, plants, and animals in their journals to communicate their findings to others. Today's diarists draw for fun and expression rather than necessity. Whether documenting travels, daily experiences, recipes, memories, or special projects, simple doodles add whimsy and enjoyment to any journaling practice.

While the borders, banners, and frames discussed in the last chapter serve function, doodles are purely ornamental. They can transform dull, depressing task lists into vibrant spaces that ignite ambition and encourage the imagination. They can be the whole point of the journal or an afterthought, sketched into corners and blank areas when you are on the phone, sitting in a waiting room, or listening to a class lecture (not that I encourage daydreaming in class, but come on...we all know it happens).

Unlike other forms of drawing, doodles don't require artistic talent. They're not high art, after all. Doodles are simple and casual—an absent-minded activity that entertains. So, your giraffe looks like a cat? No biggie! Accuracy isn't really the goal here. If it were, most people would simply paste photos in their journals. There's no inherent *need* for exquisite drawings in our journals. We simply enjoy the creative process, and as it turns out, this has value of its own.

Everyone comes to journaling with different artistic comfort levels. Beginners can gain confidence by following the step-by-step instructions in this chapter. I've also included a doodle page at the end of each section to stimulate the imagination. Recreate my drawings in your journal, or use them as a jumping-off point to inspire your own artistic endeavors.

DAILY LIFE DOODLES

A positive outlook can improve even the most mundane tasks. This group of doodles is inspired by routine. Daily workouts, laundry, and car maintenance may not be glamorous, but these activities play an important part in our lives. Instead of treating them as trivial, celebrate them in your journal with color and art.

Paper planner enthusiasts often use miniature stamps to add pretty touches to their agendas. Create tiny versions of these doodles to mark information throughout your journal. This draws attention to important information on the page, and also makes your journal a fun and expressive place to arrange your life.

Pen & Pencil

Pens and pencils play an important role in our lives from our earliest days in school. Add these cute doodles to pen pal trackers, reflection pages, or school schedules.

To draw the fountain pen:

- Step 1: Begin by drawing the pen cap. It will be flat on the bottom, rounded on the top, and slightly wider than the rest of the pen body.

- Step 2: Draw a long, narrow rectangle to represent the barrel of the pen. It should be narrower than the pen cap. Adding a slight curve to the bottom side will add dimension to your pen.

- Step 3: Add a small rectangle to represent the grip section. Again, you may add a slight curve to the bottom line if you want more dimension. Draw a clip on the side of the pen cap, if desired.

- Step 4: Finally, draw the pen nib. It should be wide at the top (near the pen grip) and taper down. Add color and decorate as desired.

To draw the pencil:

The pencil has a similar shape, but I find it easier to draw the bottom section first.

- Step 1: Begin by drawing the shaft of the pencil (pointed at the bottom and flat at the top).

- Step 2: Add the eraser holder above the shaft. It should be roughly rectangular with ridges or waves on the sides.

- Step 3: Draw the eraser at the top. It should be slightly rounded at the top.

- Step 4: Add lines to create ridges and darken the graphite point of the pencil. Color and decorate as desired.

Washing Machine

A washing machine (or most large home appliances, for that matter) is shaped like a box with a few distinguishing features. Here's an easy way to doodle a washing machine.

- Step 1: Draw a rhombus. This will give your washer a sideways perspective.

- Step 2: Add depth to the washer by adding parallel lines to the top and side of the rhombus. Connect at the corners.

- Step 3: Draw the washer door, buttons, and display panel where desired. You can easily change these elements to represent an oven, dishwasher, or dryer. Color and decorate as desired.

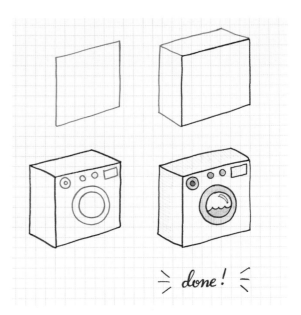

Little Car

Getting around is an important part of daily life. This happy little car just might help you view the morning commute from a brighter point of view. It works well as a calendar reminder for car loan or insurance payments, or renewing vehicle registrations.

- Step 1: Begin by drawing two equal circles to represent tires.

- Step 2: Add a front bumper and back bumper. Connect both bumpers with a line following the curve of the tires.

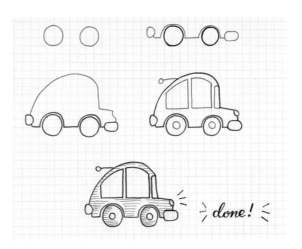

- Step 3: Draw the basic profile of the car roof and hood. I like the funny aesthetic of a tall, round car. You can adjust this shape to your desired style.

- Step 4: Add details such as windows, hubcaps, headlights, and an antenna. Color and decorate as desired.

More Life & Planning Doodles

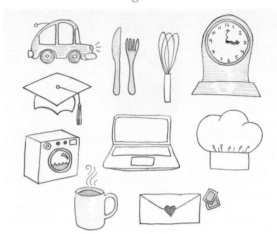

NATURE DOODLES

The world around us holds the greatest sources of beauty and intrigue. Adorn your pages with nature-inspired doodles to make every day feel like a walk in the park.

Daisy

Cheerful daisies are very easy to draw, even for novice artists.

- Step 1: Begin by drawing a small circle to represent the center of the flower.

- Step 2: Add a single layer of petals around the center. Flower petals vary in nature, so don't be overly concerned with making them perfect. Try adding notches and folds to make your flower more realistic.

- Step 3: Without overlapping the first layer of petals, add a second layer. Make this layer slightly irregular, and leave space for one more layer.

- Step 4: Fill any remaining gaps with more flower petals. Add color and detail as desired.

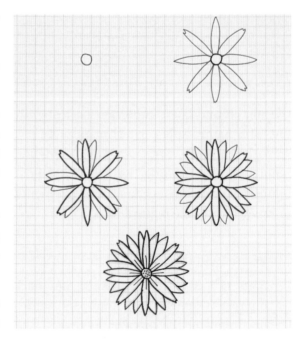

Pinecone

Pinecones are some of the most interesting shapes in nature, and they bring the rugged intrigue of the outdoors wherever they go. They're especially handy for creating cozy winter journal pages. No need to be intimidated by how detailed they seem. This easy technique only takes a few minutes.

- Step 1: Draw a rough, rounded cone shape. As you draw the outline, create shallow waves that get smaller as they approach the tip of the pinecone.

- Step 2: Beginning at the large end of the cone, draw a line of scallops. Add another row, but offset it. The points of each new layer of scallops should rest on the curves of the previous layer. Shrink the scallops slightly as they approach the point of the cone, and continue until the whole cone is filled.

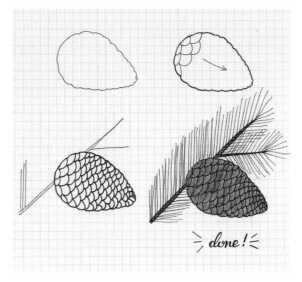

- Step 3: Draw a branch behind the pinecone. Add a few smaller offshoots.

- Step 4: Add pine needles to the branch and color as desired.

Dandelion Puff

Where some see a weed, others see a wish. Dandelion puffs are delicate, lacy, and hopeful. They are delightful reminders of the powers of optimism. Add this doodle to pages dealing with gratitude, goal-setting, inspirational quotes, affirmations, or anywhere you want positivity to take precedence.

- Step 1: Draw a small dome to represent the center of the dandelion. Add a collar of downward pointing leaves.

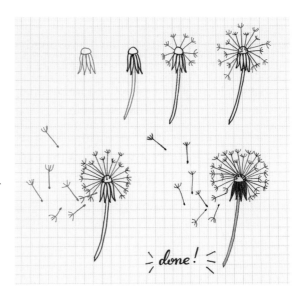

- Step 2: Create the stem of the dandelion.

- Step 3: Add a ring of short lines and draw a puff at the end of each line (these are the individual puffs that carry the dandelion seeds). Add another ring of these, but with longer lines. Making the lines different lengths will keep the puff head from looking sparse at the center. Repeat until the dandelion puff head is filled to your liking.

- Step 4: Draw lines at irregular angles floating away from the dandelion head. Add a small dot at the end of each line (representing the seed) and a puff at the other end. Color and add detail as desired.

More Nature Doodles

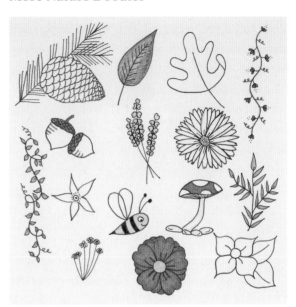

SEASONAL DOODLES

Adding seasonal doodles is just one more way to celebrate the yearly cycles. Try these easy examples, then add artwork inspired by your own life.

Winter Lights

Few things take the edge off the winter chill like the sparkle of holiday lights. These doodle lights are some of the easiest you can make.

- Step 1: Draw a wavy or looped line. Adjust the length to fit your desired space.

- Step 2: Add short tick marks along the line. Each of these will have a light at the end, so keep spacing in mind.

- Step 3: Draw teardrop bulbs on the end of each tick mark. Color and decorate as desired.

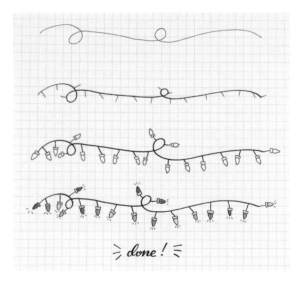

Spring Rain Boots

Puddles, anyone? Rainy day blues are no match for yellow rain boots.

- Step 1: Begin by drawing a simple boot outline.
- Step 2: Add the second boot. It will be partly hidden behind the first, but they should be roughly the same size.
- Step 3: Draw a wavy line (or oval) around the soles of the boots to represent a puddle. Add ripples in the water. Color and decorate as desired.

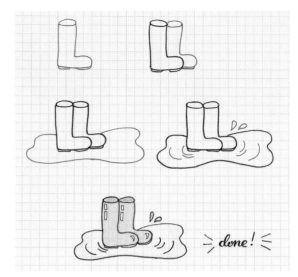

Summer Lounge Chair

Most summer doodles involve sunshine and sand, but this one also emphasizes relaxation. Lounge chairs are a central part of most summer gatherings, and they remind us to slow down occasionally.

- Step 1: Begin by drawing a curved paddle shape. This will be one of the arm rests.
- Step 2: Add lines to represent the front and back legs of the chair (leave the back leg open at the bottom).
- Step 3: Draw the back rest, but leave it open at the bottom.
- Step 4: Add the seat of the chair. Make sure the lines do not cross the front chair leg.
- Step 5: Make sure the chair back extends all the way to the base of the chair (you can

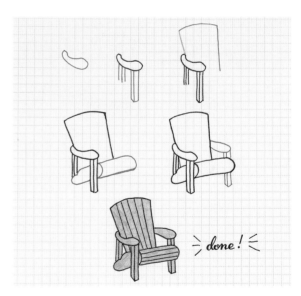

see I added a small red line to represent the chair back peeking out from under the arm of the chair). Add the other chair arm and front leg. Color and decorate as desired.

Fall Leaf

The nature section of this chapter also features leaves, but curled leaves are a little trickier. Plus, they're almost obligatory in autumn. You'll master them in no time.

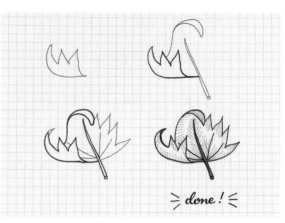

- Step 1: Begin by drawing a curved line. Close it with leaf points on the top side.

- Step 2: Add the tallest part of the leaf. Sweep it to a point, then double it back on itself. Draw the stem leading up to the tallest part of the leaf.

- Step 3: Close the rest of the leaf with jagged points. Add details (any remaining folds in the leaf and the veins). Color and decorate as desired.

More Seasonal Doodles

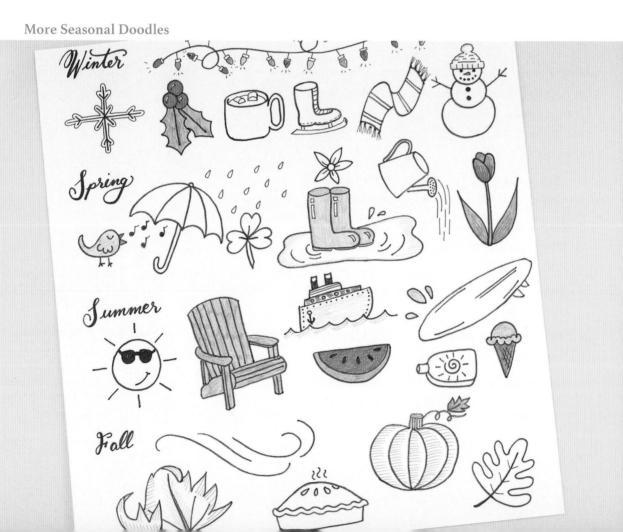

TRAVEL DOODLES

Whether making plans for future travel or documenting your experiences in new and exciting locations, these doodles will set the stage for grand adventures.

Hot Air Balloon

Hot air balloon doodles are a fun, easy way to indulge flights of fancy. You can create variety with different patterns, colors, and decorations.

- Step 1: Begin by drawing a dome with a scalloped edge on the bottom. Add two more lines of scallops. These will look like fabric swaths at the widest part of the balloon.

- Step 2: Add curved lines to the dome (seams), and extend the lower part of the balloon downward.

- Step 3: Draw a basket below the balloon.

- Step 4: Connect the balloon (beginning from the swaths) to the basket with straight lines. Color and decorate as desired. Flags, ribbons, and signs also make nice additions to hot air balloon doodles.

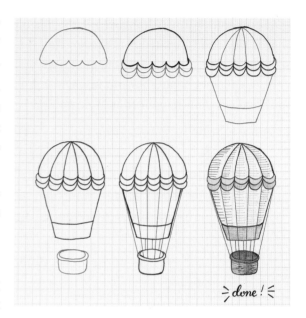

Suitcases

Don't forget the luggage! Baggage is, of course, as essential part of traveling. These suitcases are doodled as basic boxes, but a few decorations transform them into adorably old-fashioned luggage.

- Step 1: Draw a rhombus, add vertical lines at the lower corners, and connect them. It should look like a rectangular box.

- Step 2: Without overlapping lines with the first box, add a larger box underneath.

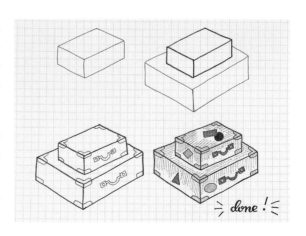

- **Step 3:** Create a handle and add details to the corners of each box.

- **Step 4:** Add other decorations (stickers, stamps, wheels, luggage tags, etc.) and color as desired.

Globe

Nothing says travel like maps and globes. They guide us and help us imagine all the far-off places we might someday discover for ourselves. This basic globe is easy to make, but you can also play with patterns and unusual colors to add a little flair to your travel journaling.

- **Step 1:** Begin by drawing a circle.

- **Step 2:** Add notches at the top and bottom of the globe (these represent the axis). Following the curve of the globe, add an arm to connect the top and bottom of the axis.

- **Step 3:** Create the base of the globe. Color and decorate as desired.

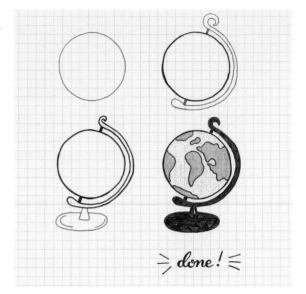

More Travel Doodles

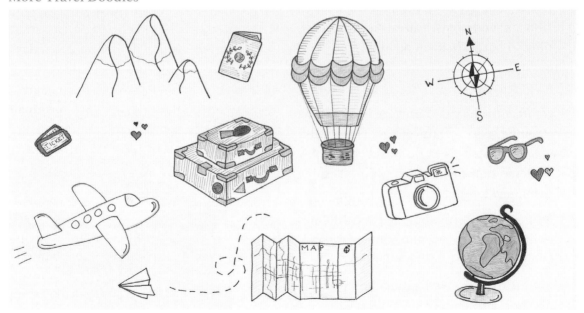

Inspiration from Real Journals

I've filled this book with templates and visual elements to inspire many styles of journaling. Some pages are from my actual journals, while others are blank templates that have not been lived in. However, each person has a style that is exclusively his or her own. Even when I try to present different styles, they are a product of my experiences. It would be foolish to pretend that any single person could represent the boundless ways people use notebooks, journals, diaries, and planners to improve their lives.

Instead, I have called on members of the online journaling community (whose exuberant creativity far surpasses my own) to show you their unique approaches. Some innovation in the journaling community comes from leading brands and social media influencers, but far more comes from individual journal users who swap techniques with their social circles. Many people claim keeping a journal has transformed their lives in meaningful ways. Rather than hiding diaries under their mattresses, modern journalists are opening their personal notebooks to the world to inspire and encourage others in the practice. The variety created by this culture is what makes today's journaling styles so energetic.

All photos are used with permission, and I am deeply grateful to each of these individuals for lending their talents to this book.

THE ORGANIZED STUDENT

University and high school students use journaling to organize their schedules, track assignment due dates, and relax with a fun creative outlet. Maggie Kan, a student and journaling enthusiast from the United Kingdom, shares her journal pages on her Instagram account (Instagram.com/studywithmaggie). Her clean, colorful journaling style has attracted tens of thousands of followers who seek to improve their own productivity systems.

Maggie started journaling in 2016 as a way of organizing her academic and social life, but the habit evolved beyond mere organization.

"My journal isn't only a planner," she says. "It's a creative outlet [that] lets me explore different styles without the pressure of needing to create something perfect." One of her favorite aspects of this approach is flexibility. She shifts freely between simple task lists and intricate drawing in her travel pages. "The possibilities are endless," says Maggie. "I cannot wait to see where my journaling adventure takes me and what new things I'll learn along the way."

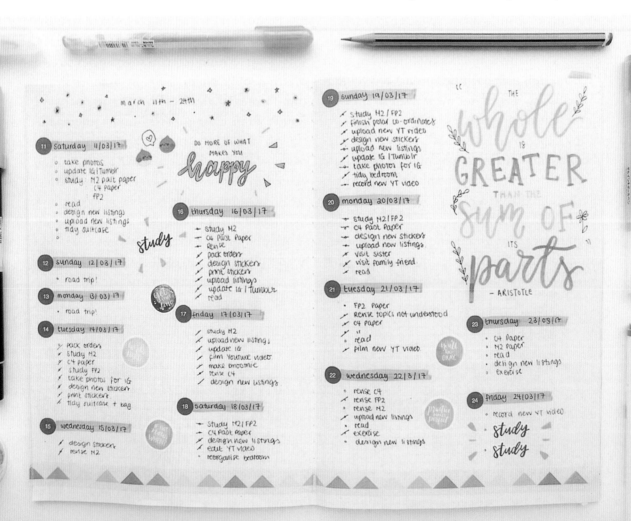

CREATIVE PLANNING LAYOUTS

Whitney Baker loves creating unusual planning templates in her journal, which she decorates with colorful hand-lettered headers. Instead of following conventional planning layouts, she likes to shake things up with diagonals, braided lines, and offset grids (like the one shown here). She even shares before and after photos of her pages so other journaling enthusiasts can see how different layouts work in practice.

"Each week is a new beginning for me," she says. "I try to design new layouts every time I can." In this January monthly layout, Whitney used a shape-tracker to keep up with healthy habits and her website's social media statistics. On the right side of the spread, she listed "Blog Things" and "Me Things" to keep up with her personal gratitude practice and blogging milestones.

"It's fun to look back on short little snippets about my day, and even more fun to reach the goals I set at the beginning of the month." Whitney shares her passion for organization, drawing, and paper planning on her popular lifestyle blog (lifebywhitney .com) and Instagram account (Instagram.com/ lifebywhitney).

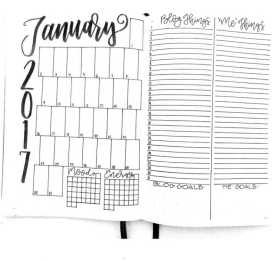

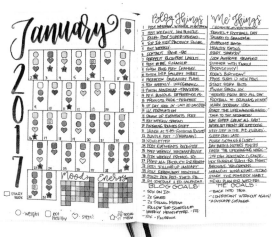

BUILDING BETTER HABITS

Artist and creative blogger Shelby Abrahamsen (littlecoffeefox.com) keeps one eye on planning and the other on creativity. As a young business owner, Shelby uses her journal to establish good habits and set goals for the future. Mastering productivity and overcoming procrastination are common themes on her website, but she also infuses her journal

with art and color. Her pages frequently feature watercolor illustrations, and she even uses painting techniques to create vibrant headers.

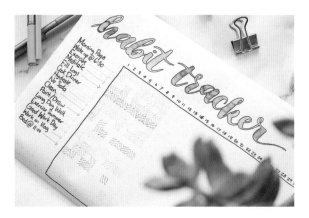

Shelby's full-page habit trackers are valuable tools for understanding her work rhythms. The line patterns in her habit tracker boxes are especially eye-catching, and they add a hefty dose of fun to an otherwise businesslike behavior chart.

JOURNALING FOR EXPRESSION

For some people, the creative aspects of contemporary journaling are the whole point. Visual artist Torrie Gass (www.foxandhazel .com) uses her journal to document her emotions. Her journaling style is more about sorting emotions than task lists. She includes few (if any) words in her pages and focuses instead on color, texture, and abstract elements of life experiences.

"I find that using color and imagery is a nice break from writing words," she says. "I need a way to decompress most days, and pushing paint around on a page is a great way to do that." The process helps her work through thoughts, feelings, events, and problems in the same way written words help more traditional diarists.

MEMORIES & SKETCHES

Mother and journaling enthusiast Helen Colebrook uses her creative journal as a tool for reflection and memory-keeping. She tries to make time each day for a short entry, along with a colorful sketch to document her life with her family. "I love looking back through it with my daughter and remembering the little moments that make life special," she says. In addition to a short written entry, her pages often contain small sketches, stickers, or patterned washi tapes to give them just the right amount of visual intrigue. See more of Helen's artwork and journaling ideas at instagram .com/journalwithpurpose.

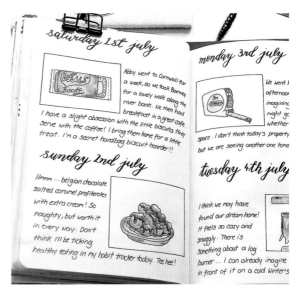

KEEPING A BALANCE

Instead of letting chaos take over her family, Sheena uses time blocking and intentional planning to keep things in balance. As a busy mother of three, she relies on her planning pages to track her family's schedule as well as her own.

Her typical weekday timeline gives her a valuable snapshot of her most effective times of day, as well as crunch points that create stress and chaos. The right page shows how she uses principles of time blocking to accomplish groups of tasks. Planning ahead allows her to accomplish tasks proactively, as opposed to reacting to the chaos of her environment, especially when family needs take precedence. Not only does Sheena's journal give her a quiet space to express herself, but it also allows her to fulfill the many roles she plays in life. Read more about Sheena at sheenaofthejournal.com.

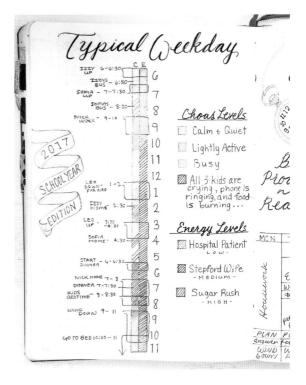

PHOTO REFLECTIONS & MEMORY PAGES

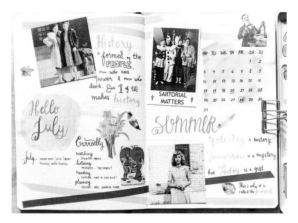

London fashion blogger Nora (Instagram.com/norajournals) started journaling in February of 2017. She finds that it offers a reprieve from the constant barrage of online advertising and shopping temptations that come with working as a fashion blogger.

Pouring energy into something creative has also supported her through various personal struggles. She speaks openly about how journaling helped her process the anxiety and grief she felt after losing a close friend to suicide. Many of her pages involve memories, travel experiences, and encouraging words, and the artwork often has a classic or vintage aesthetic. The colors are generally cheerful—lots of oranges and yellows—evoking happiness and optimism. Nora says daily journaling helps her keep things in perspective and has been a positive force in her life.

VISUAL TIME MANAGEMENT

Journaling has a diverse international following, attracting enthusiasts from all over the globe. Tímea Nagy (Instagram.com/timi_kincsesfuzet) is a Hungarian blogger and administrator who uses her journal for personal enjoyment, planning, and mental health. She took up journaling during a particularly turbulent period of her life following the death of her mother and a stressful transition from student life to a new job.

Tímea focuses on using her journal as a tool for managing stress. "Creative journaling itself is a great process," she says. "The time I dedicate to filling [my journal] makes me slow down and become more mindful. Creating something, writing, and drawing are my 'me' time activities." She says she's constantly inspired

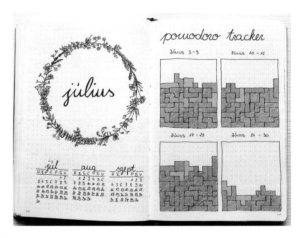

by the joys of her life, as well as other styles she learns from the journaling community.

This page from her notebook is particularly interesting, and there is a whole system behind it. She tracks different types of activities using

the Pomodoro Technique, which is based on 30-minute time blocks (one Pomodoro = 25 minutes + a 5-minute break). See the Resources section for more information.

Pomodoros are often represented as tomatoes, but Tímea prefers to color a square in her journal for each 30-minute block. The pink blocks represent time spent on recreational activities, gray blocks represent work, and teal squares represent chores or other small tasks. She groups individual squares into 2-hour blocks and fits them together. Her patterns were inspired by the video game Tetris®. "I use this pattern instead of simply coloring the squares individually because...well, I just like the style." For more information about her journaling techniques, visit her blog at kincsesfuzet.hu.

PERFECT PAPER PLANNING

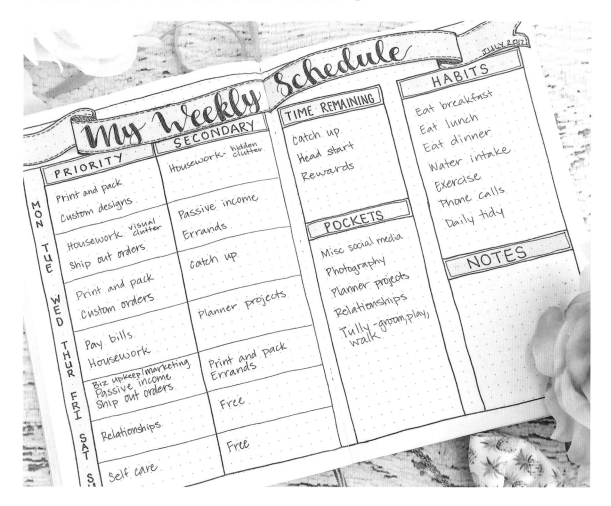

As a paper planner enthusiast, Meka Allen shares many of her planning strategies on her Instagram account (Instagram.com/yespleaseplanning). In addition to a traditional planner, she uses her journal to create simple weekly schedules. She prioritizes tasks from big to small, leaving the simplest tasks for pockets of time throughout the week. She enjoys adding small decorative touches, but her pages remain practical and easy to read.

She also uses her journal pages to track her progress on more specific goals, such as budgeting. In her page to the right, she acknowledges the temptation she experiences when interacting with her hobby groups. She uses this awareness to avoid overspending and tracks her progress with a handmade chart.

Meka creates meaningful layouts without going overboard. In the quest for the "perfect" planner system, people often overcomplicate things. Meka's pages show that simplicity can be the most effective system of all.

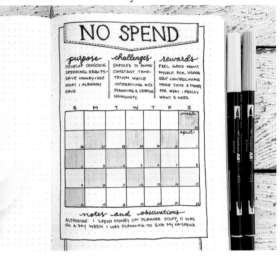

CUSTOMIZED FITNESS TRACKERS

When it comes to health and fitness, each person has different needs and goals. Erin Nichols uses her journal to create custom workout trackers. As a busy mother, blogger, and fitness enthusiast, she needs layouts that track her individual goals. Whereas many premade health trackers measure only weight, Erin takes a more holistic approach. She tracks everything from weight, measurements, individual workout sessions, and water and food intake. Since her journal has been instrumental to her own success, she started a website to share her planning and journaling strategies. Check out more from Erin at thepetiteplanner.com.

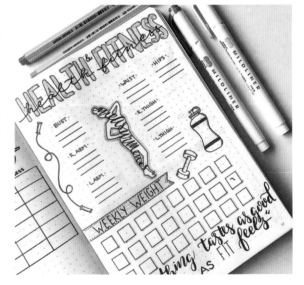

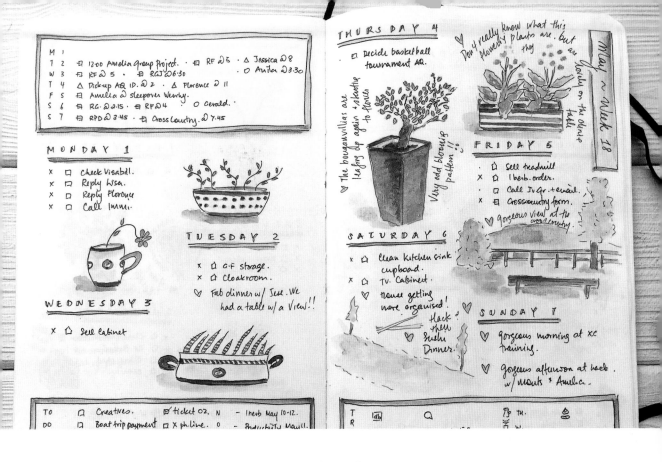

TASKS AND REFLECTIONS

It's not always easy to decide if a journal is a hobby or a tool (and maybe that's a good thing). Denise Qvist (Instagram.com/digplans) blends these two functions with incredible grace. Her task lists are seamlessly integrated with her artworks. She moves easily between creating watercolor illustrations and short to-do lists.

Denise's affinity for nature is apparent in most of her pages, and she often adds quick sketches of plants and landscapes next to her everyday task lists. She also shares photos of her travel pages, packed with watercolor sketches and written observations of the country she is visiting. Unlike a standard task list, flipping through one of her old journals would be a rich artistic experience.

These journals are very different, but they reflect the style and needs of their creators. From artwork and self-expression, to family life and task management, the possibilities within these pages are infinite. Experiment along the way, and adapt as needed. Over time, you will discover your own approach, whatever that may be, and it will be better than anything I've suggested here. Journaling has become a treasured part of my life, and I hope your endeavors bring you as much joy. Have fun, embrace challenges, and celebrate each day.

Happy journaling!

RESOURCES

No system works perfectly for everyone. The additional resources listed here are frequently incorporated into journaling or planning habits, to varying degrees. Explore what they have to offer at your leisure and decide which techniques are right for you.

The Bullet Journal®

A simplified journal-based productivity system. This brand has its own notebook, digital app, and a simple formula for starting a productivity journal. Learn more online at bulletjournal.com.

Franklin-Covey®

A paper-based time management and planning system first popularized in the 1980s. It places focus on goals and priorities so that tasks relate directly to priorities. Although the brand produces its own paper planning products, many of the principles can also apply to a journal-planning practice. Learn more at franklincovey.com.

7 Habits of Highly Effective People by Stephen R. Covey

This book, written by the founder of Franklin-Covey, teaches the productivity model under which Franklin-Covey operates. It emphasizes prioritization and acting on the most influential (not necessarily the most urgent) elements.

Pomodoro Technique

A time management technique built around 30-minute time blocks. It stresses intense focus, short work periods, and minimal distractions. Learn more at cirillocompany.de/pages/pomodoro-technique.

Getting Things Done by David Allen

This book covers another popular productivity method based on intentional list-making. It emphasizes breaking projects into actionable tasks.

ACKNOWLEDGMENTS

I owe thanks to countless people for making this book possible. My greatest debt is to my husband, Ethan, whose unfailing support has allowed me to pursue my passions. To the good people of the journaling community, I thank each of you for your passion, creativity, and generosity. Finally, I'd like to acknowledge Bridget Thoreson, and the entire staff at Ulysses Press, who turned my ramblings into the book you hold in your hands.

ABOUT THE AUTHOR

Megan Rutell is the writer, blogger, and journaling enthusiast behind PageFlutter.com. She spent seven years flying in the U.S. Air Force before dusting off her degrees in journalism and creative writing. She lives with her husband, two sons, a boxer named Lola, and a fat cat who runs the show.